BBC DOCTOR WHO

DOT TO DOC

Illustrations by Gary Joynes

PSS!

PRICE STERN SLOAN

AN IMPRINT OF PENGUIN RANDOM HOUSE

GET READY TO DRAW THE WHONIVERSE ONE DOT AT A TIME
WITH THIS TIMEY-WIMEY DOT-TO-DOT BOOK!

BEFORE YOU GET STARTED, HERE ARE A FEW TIPS TO HELP YOU
COMPLETE EACH PICTURE:

1 The finer the pen
or pencil you use, the easier
it will be to complete each
picture - thick lines can obscure
numbers you might need
to see later on.

2 Take care around
densely numbered areas. It's
especially easy to go wrong when
similar numbers are in close
proximity to one another!

3 Make sure you draw in a well-lit
room in order to read the small
numbers easily.

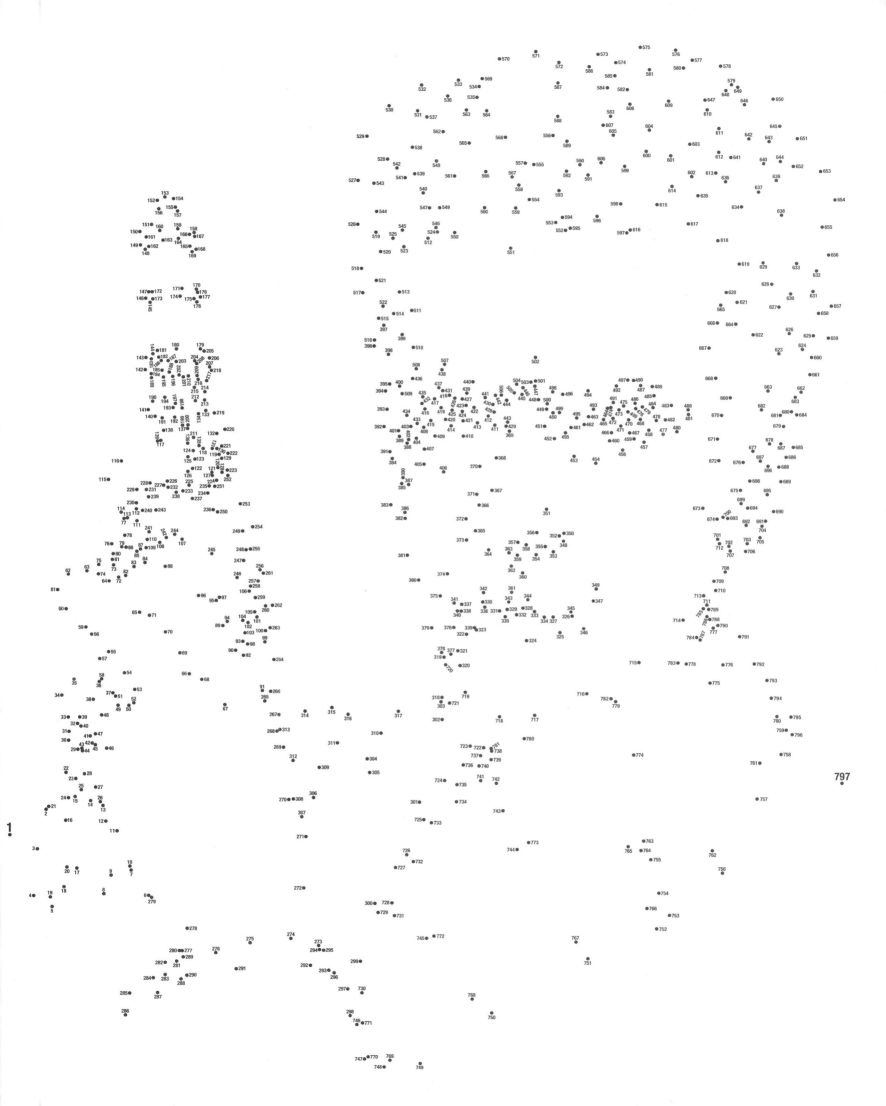

1

780

POLICE PUBLIC CALL BOX

POLICE PUBLIC CALL BOX

POLICE TELEPHONE
FREE
FOR USE OF
PUBLIC
ADVICE & ASSISTANCE
OBTAINABLE IMMEDIATELY
OFFICERS & CARS
RESPOND TO ALL CALLS
PULL TO OPEN

1

351

638

1

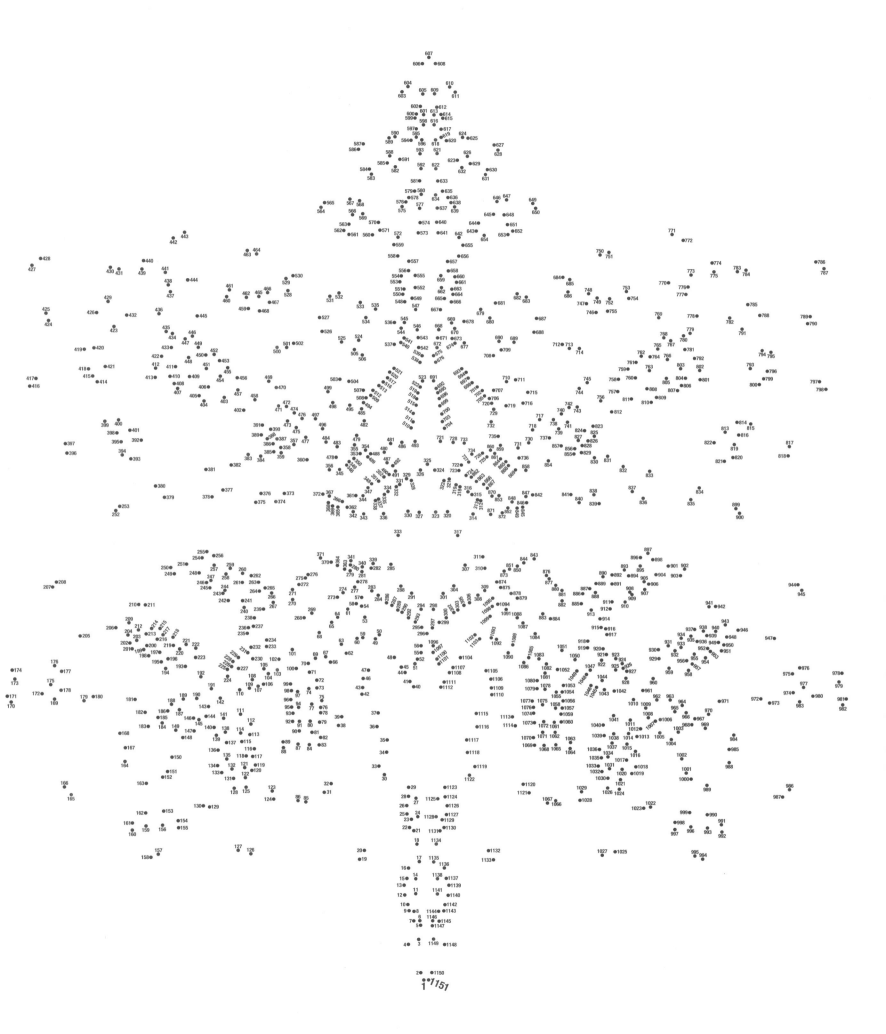

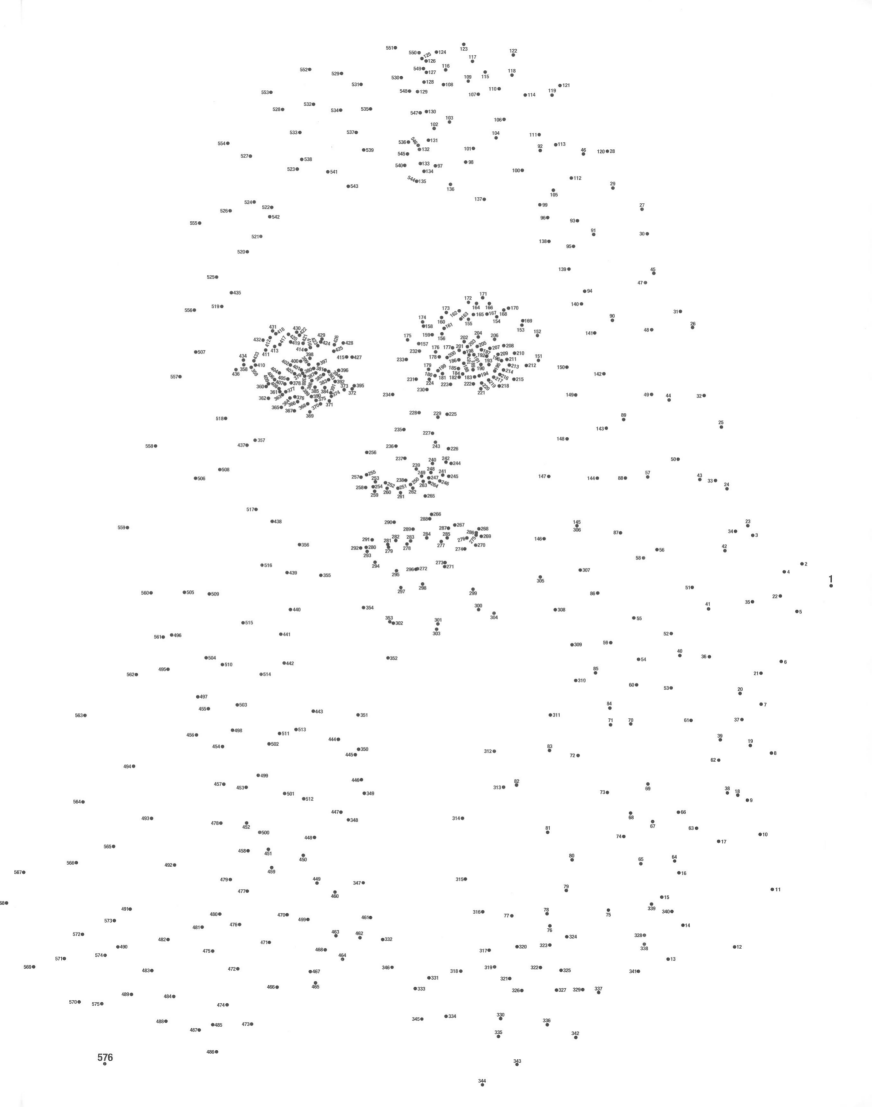

576

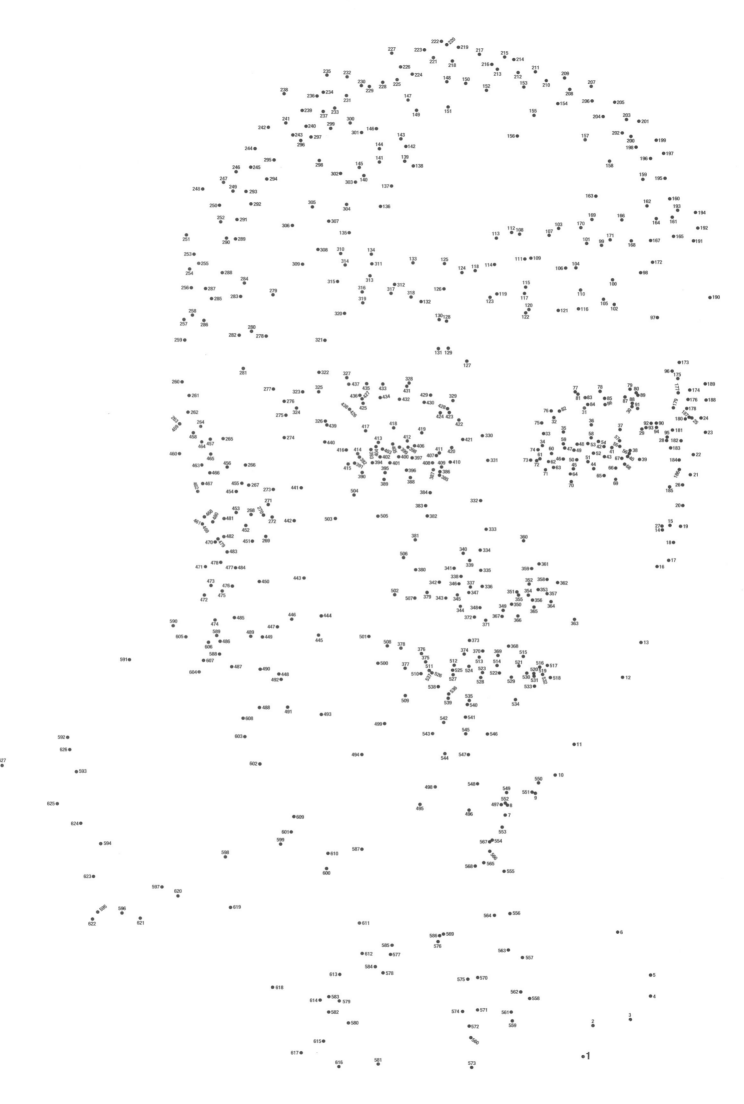

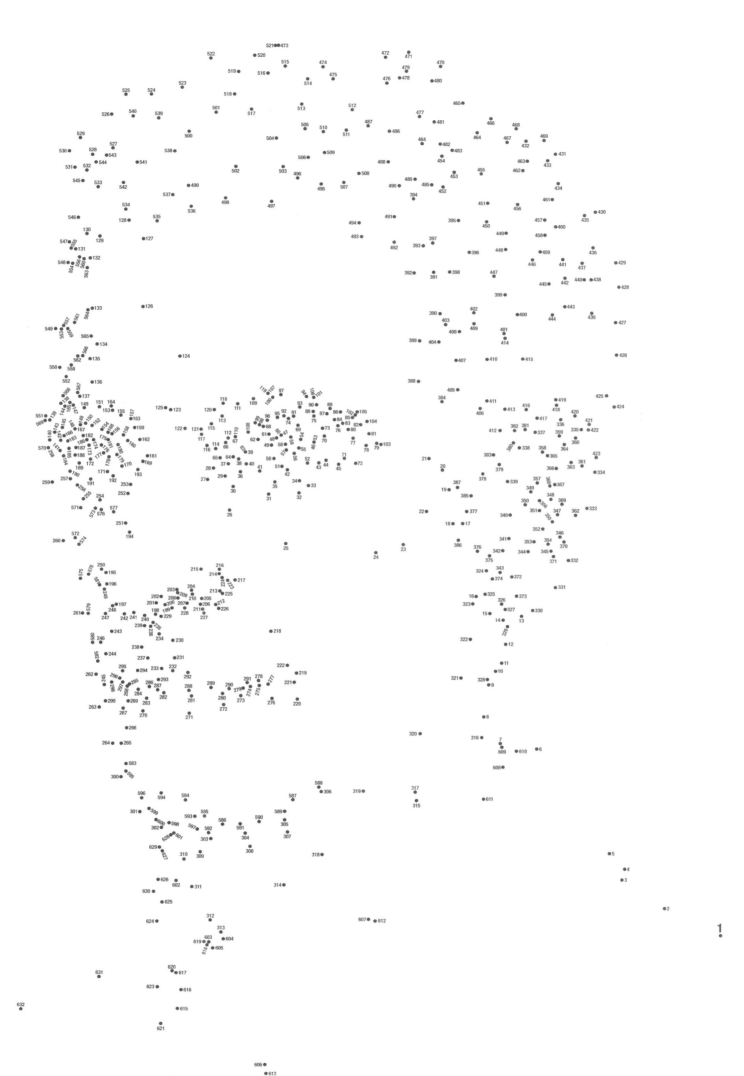

1

1221

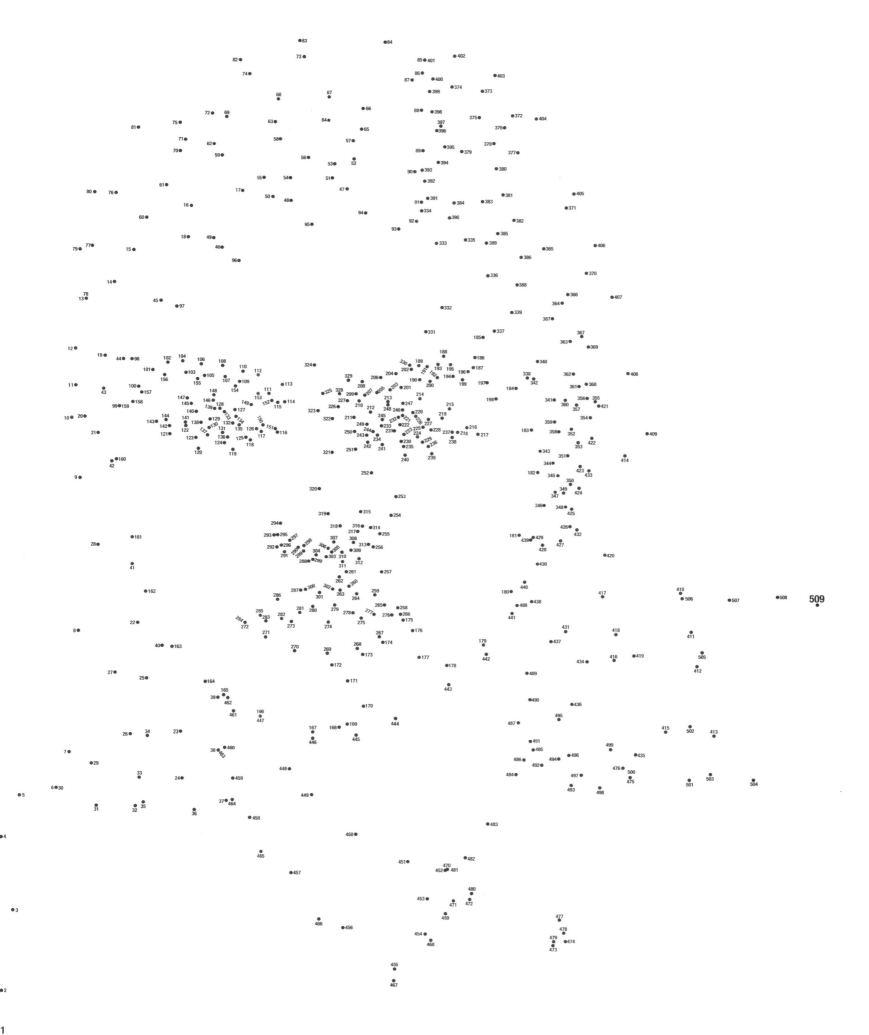

1
509

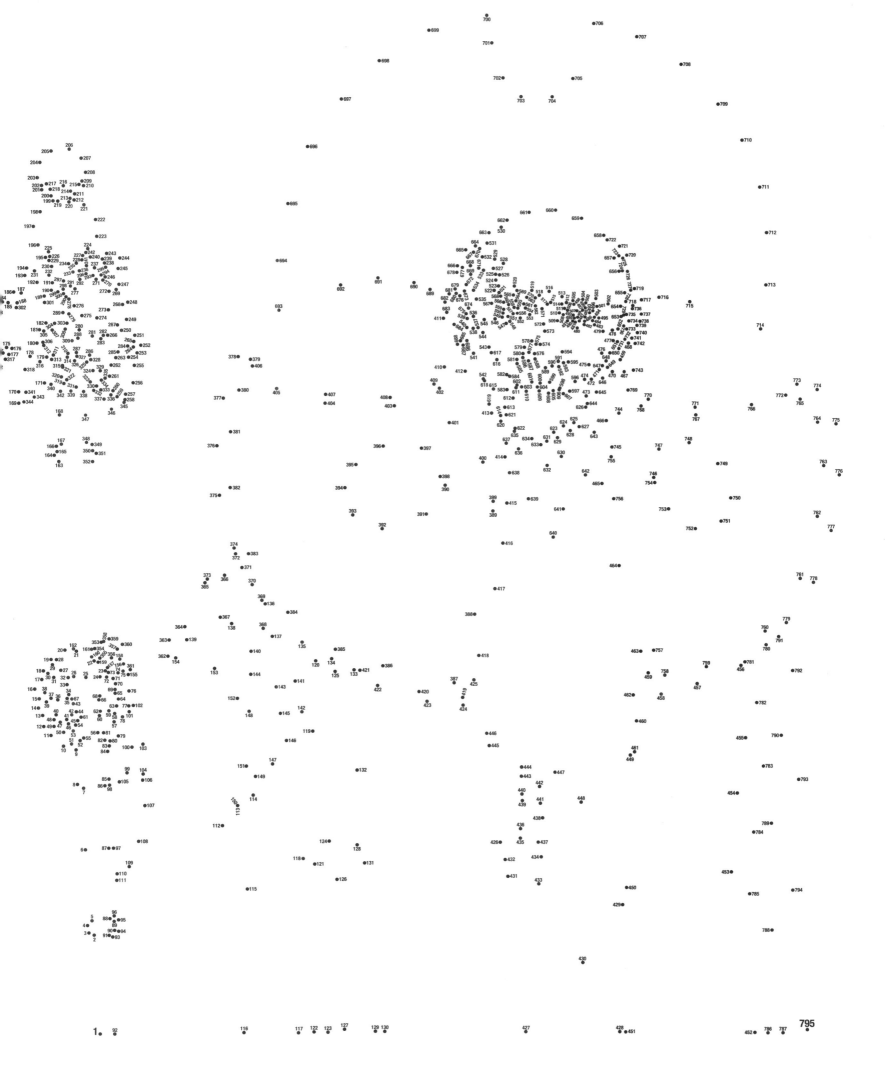

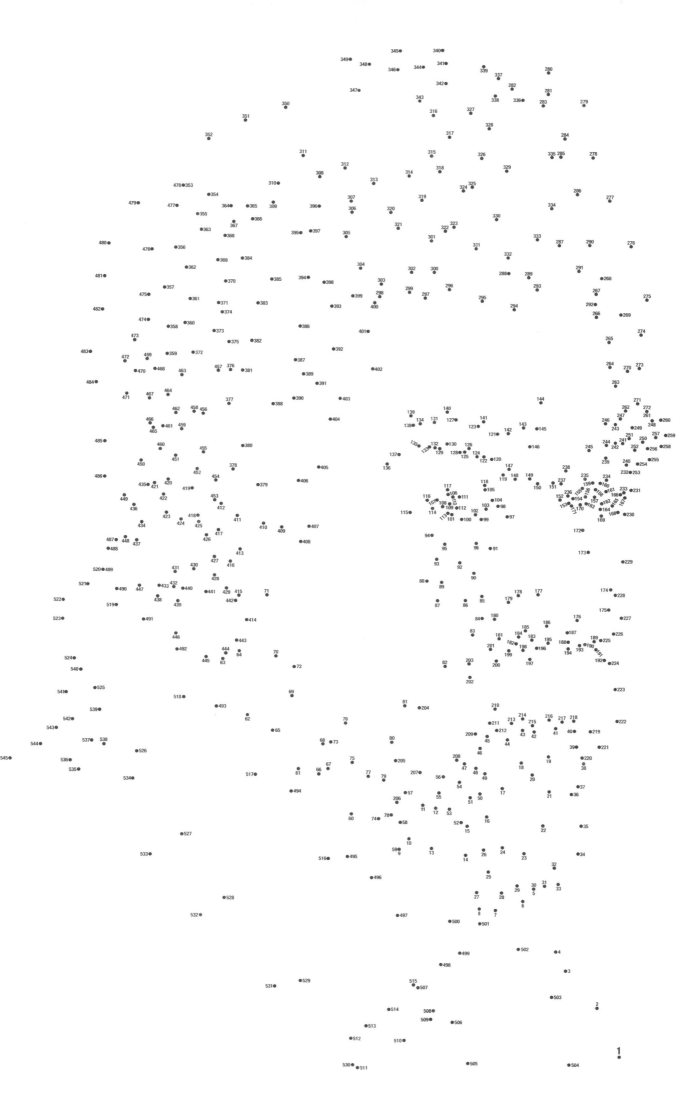

889

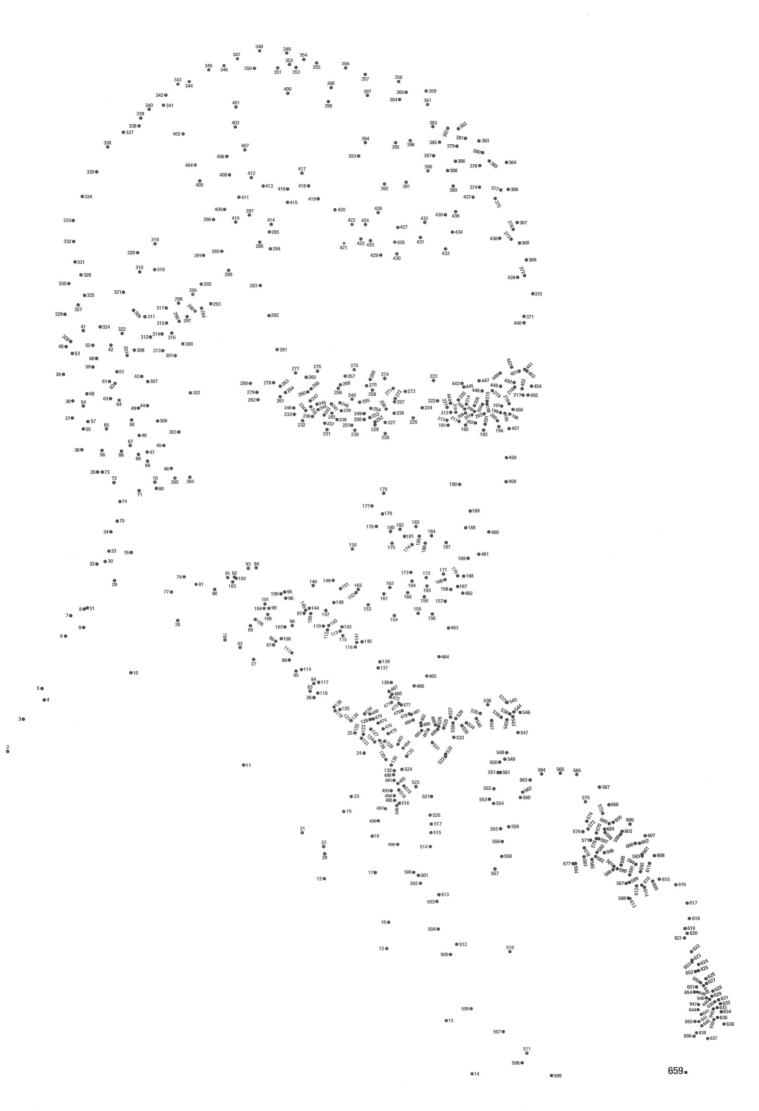

DOCTOR WHO

DOT TO DOC

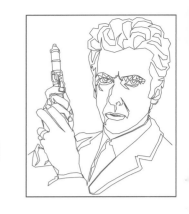

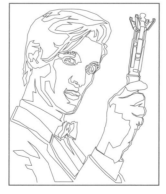 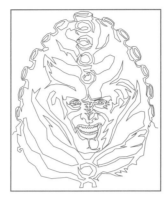

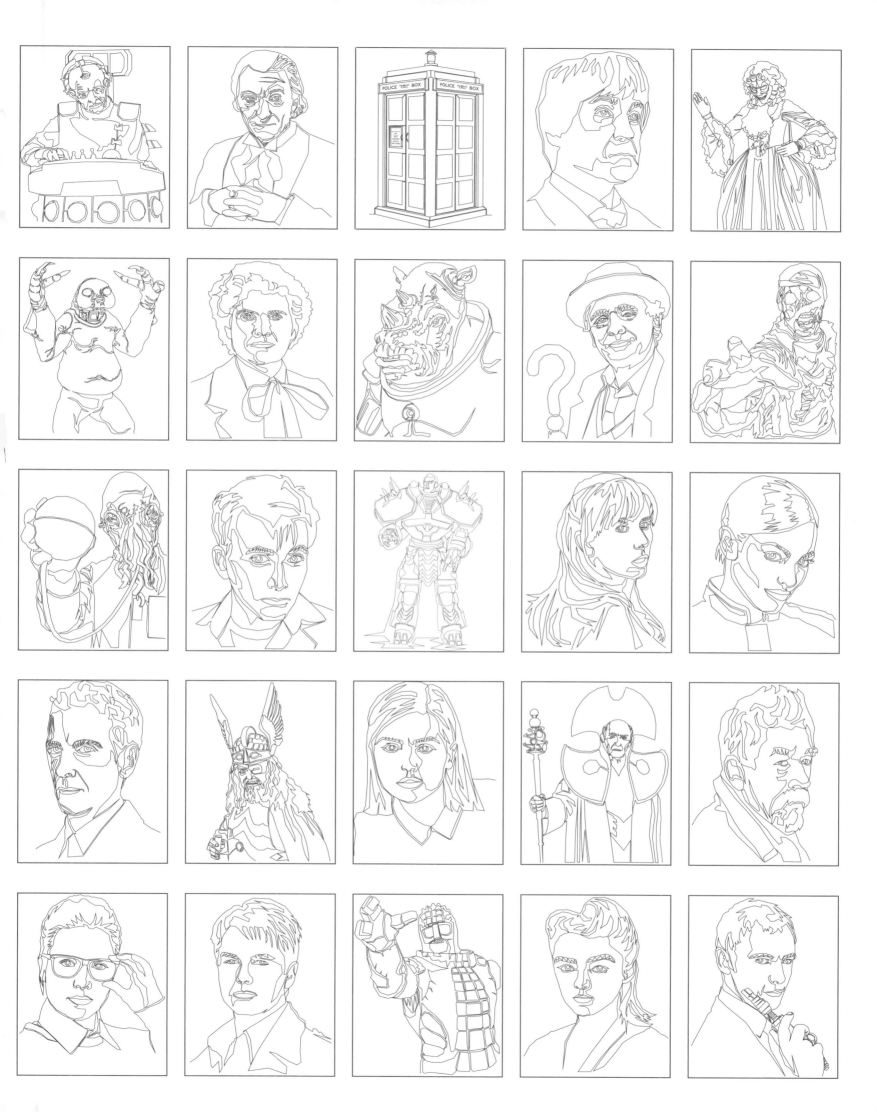

PRICE STERN SLOAN
An Imprint of Penguin Random House LLC

penguin.com
A Penguin Random House Company

Illustrations by Gary Joynes.
Copyright © BBC Worldwide Limited, 2016. BBC, DOCTOR WHO (word marks, logos, and devices),
TARDIS, DALEKS, CYBERMAN, and K-9 (word marks and devices) are trademarks of the
British Broadcasting Corporation and are used under license.
BBC logo © BBC, 1996. Doctor Who logo © BBC, 2009.
Dalek image © BBC/Terry Nation, 1963.
Cyberman image © BBC/Kit Pedler/Gerry Davis, 1966.
K-9 image © BBC/Bob Baker/Dave Martin, 1977.
TARDIS image © BBC, 1963. All rights reserved.

First published in the United Kingdom in 2016 by Puffin Books.
First published in the United States of America in 2016 by Price Stern Sloan, an imprint of
Penguin Random House LLC, 345 Hudson Street, New York, New York 10014.
PSS! is a registered trademark of Penguin Random House LLC.
Manufactured in China.

ISBN 9780451534248 10 9 8 7 6 5 4 3 2 1

THE PEOPLE

THE PEOPLE

PHOTOGRAPHS BY HUNTER BARNES

REEL ART PRESS

This book is dedicated to the Nimiipuu,
the people of the Nez Perce Tribe

**This journey with the people of the
Nez Perce Tribe took place from 2004-2008**

Tamkaliks Powwow, Wallowa, Oregon

Nez Perce Reservation, Lapwai, Idaho

Lookingglass Powwow, Kamai, Idaho

Confederated Tribes of the Colville Reservation, Washington

TRIBAL EXECUTIVE COMMITTEE
P.O. BOX 305 • LAPWAI, IDAHO 83540 • (208) 843-2253

May 19, 2009

Greetings Mr. Hunter Barnes:

It is with great respect and appreciation on behalf of the tribe that I offer you a heemqes qee'ci'yew'yew', a big thank you, for your most recent contribution to the Nez Perce Tribe's art collection. A series of forty still black and white portraits of Nez Perce people done over four years, valued at $1,000.00 each.

As per your request we will develop a loan agreement with the Nez Perce National Park Museum for storage of these images, for safe keeping.

Again, we thank you for your generous donation of this collection and your efforts to begin a legacy of photographers among our most valued resource, our future leaders of the tribe. I am sure the ground work you are making with our youth to earn an art skill such as photography will have a positive influence among the tribal community.

Best regards,

Samuel N. Penney

Samuel N. Penney
Chairman

cc: file

The People

Four years shared with the people of the Nez Perce Tribe.

Invited to the Tamkaliks Powwow, then to their home on the reservation.
Taken in by family.

Reflections of where I was invited, a vision of responsibility.

Months spent together, led to the Sweatlodge. Gaining trust and understanding. The first to be invited in many years to document The People. Time needed to trust and understand me.

Shown ways of healing and health. Living with the Dreamers, taught an ancient way.

Taught to listen from within.

Follow the Great Spirit, fly on eagles' wings.

Once a territory with no fences, a land with no borders, free to live on all the land.

Stories sharing times of hardships and enlightenment.

Stick games and dances. Taught to gather roots and berries. History lost and misunderstanding. Cutting their braids, told to choose a new name.

Camping under the stars.

Ancestors and elders, a child lights the new day.

Kaus kaus, sage and sweetgrass, tobacco used to bless the spirit.

Guided by a greater force, a new way to walk and breathe.

Walking with eyes of faith into the invisible.

A force of truth, all power and soul.

The seven drum, the four directions.

A traditional culture that has met a modern age. A century that has passed and a new world that rises.

The Great Spirit in motion, living full circle.

Shown roads hidden in sage.

I thank all of the people that have guided me through this journey and the spirit that lives within.

Nimiipuu / Ne Mee Poo
The People

Hunter Barnes

Dreamer
Tamkaliks Powwow, Wallowa, Oregon

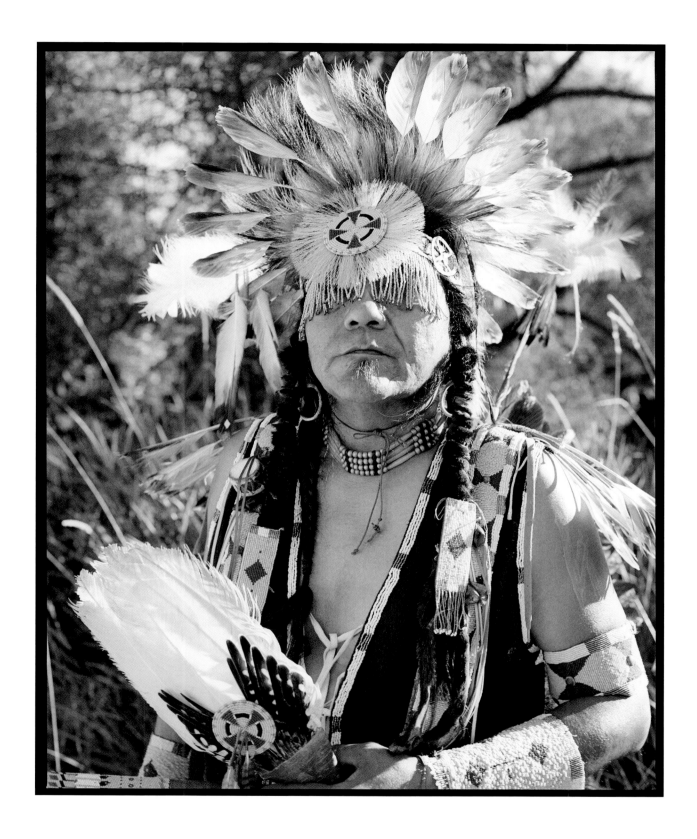

Downtown Nespelem
Nespelem, Washington

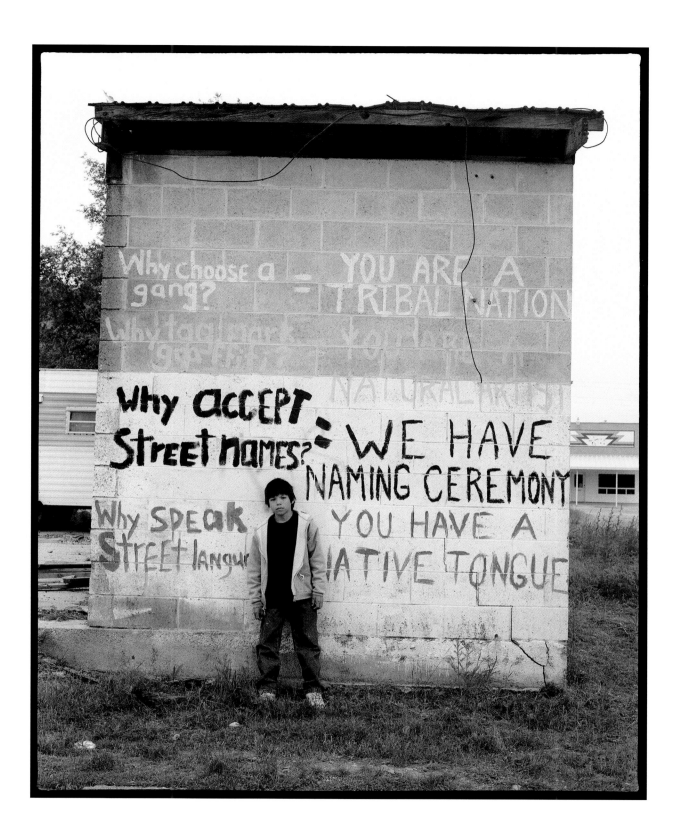

Choc's Crib
Lapwai, Idaho

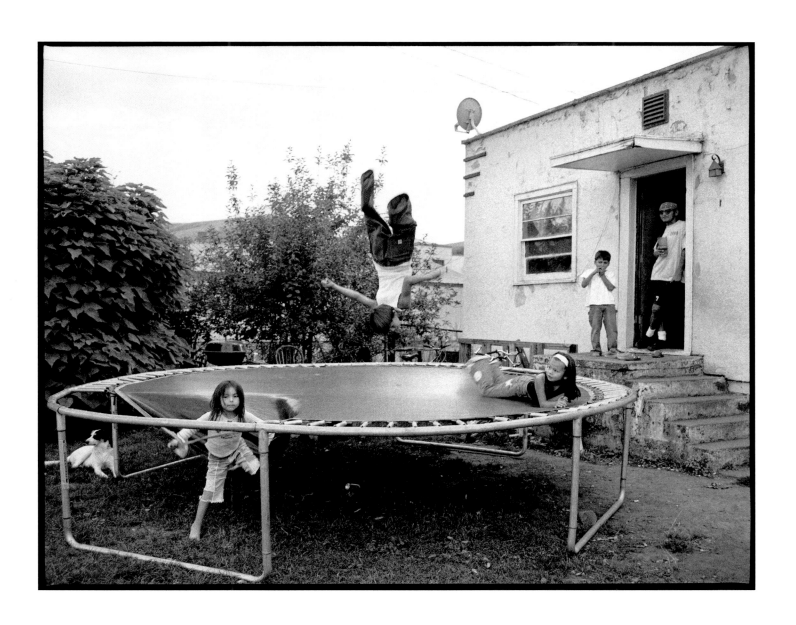

Kids
Lapwai, Idaho

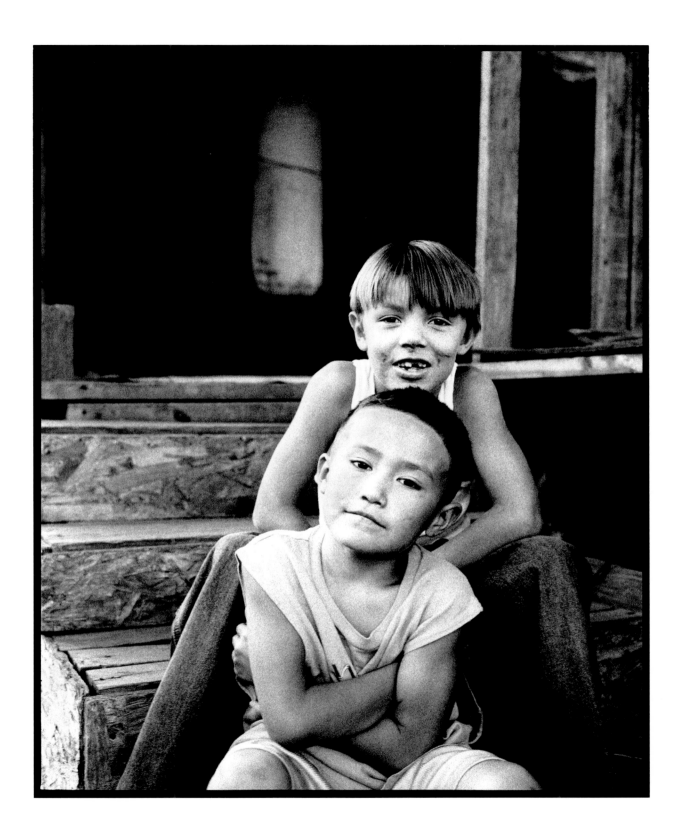

Ann Samuels
Lapwai, Idaho

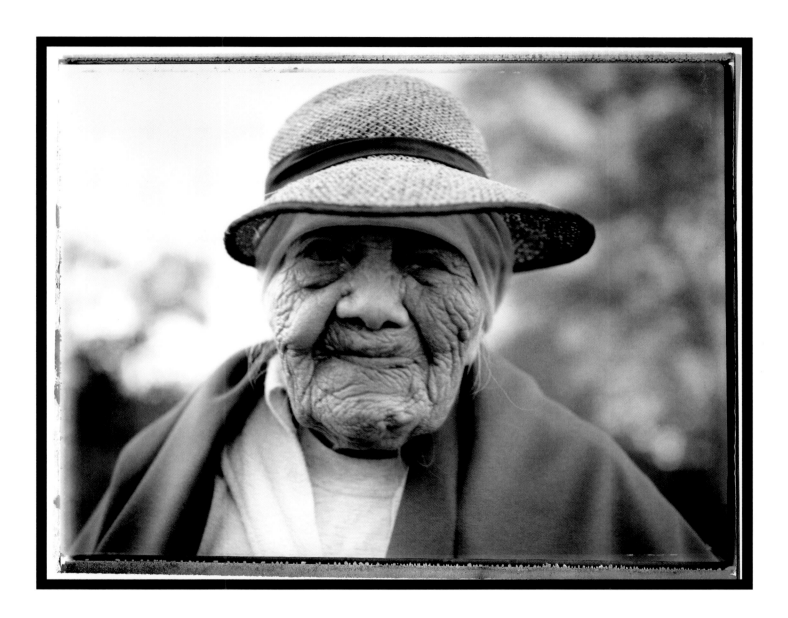

Ann and Tino
Lapwai, Idaho

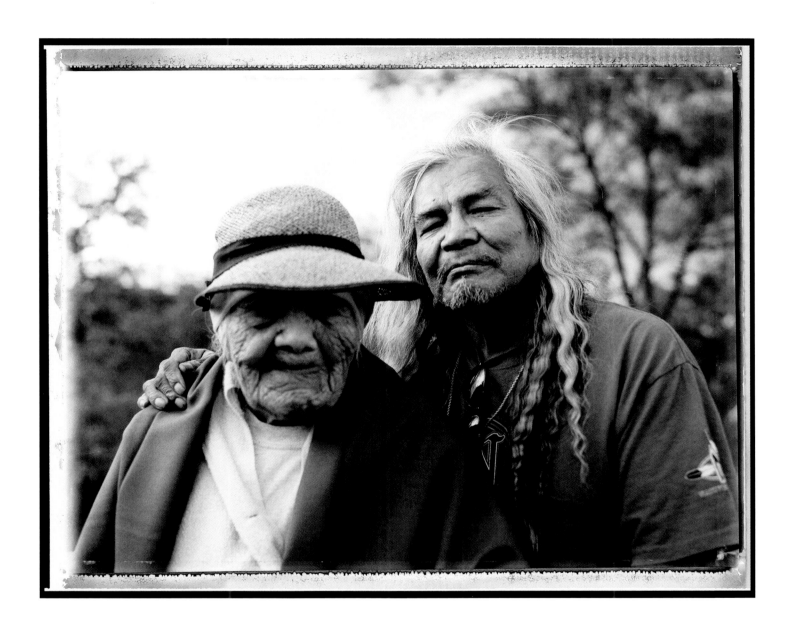

Alec Sam
Nespelem, Washington

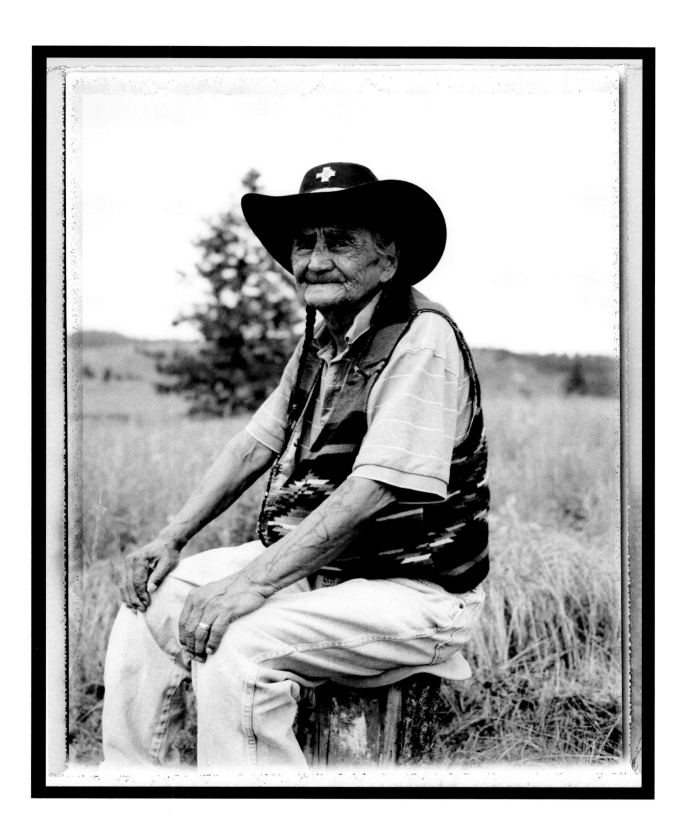

Teresa Higheagle
Tamkaliks Powwow, Wallowa, Oregon

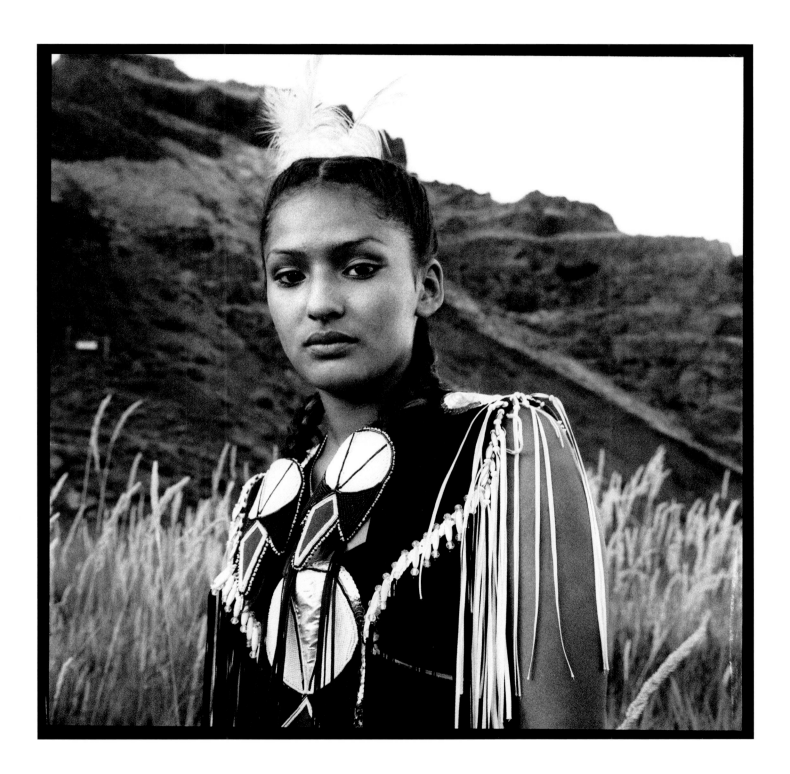

Tamkaliks
Tamkaliks Powwow, Wallowa, Oregon

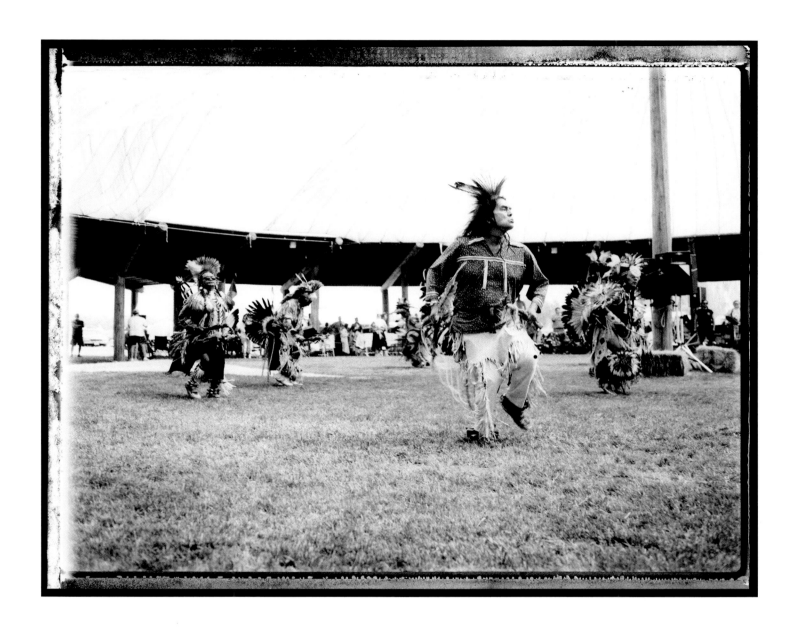

Campground
Tamkaliks Powwow, Wallowa, Oregon

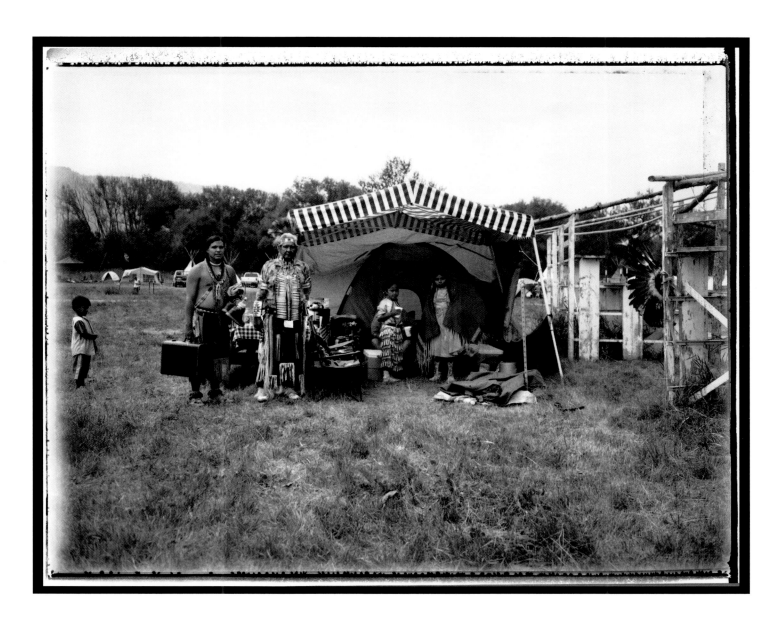

Jason and Delina
Tamkaliks Powwow, Wallowa, Oregon

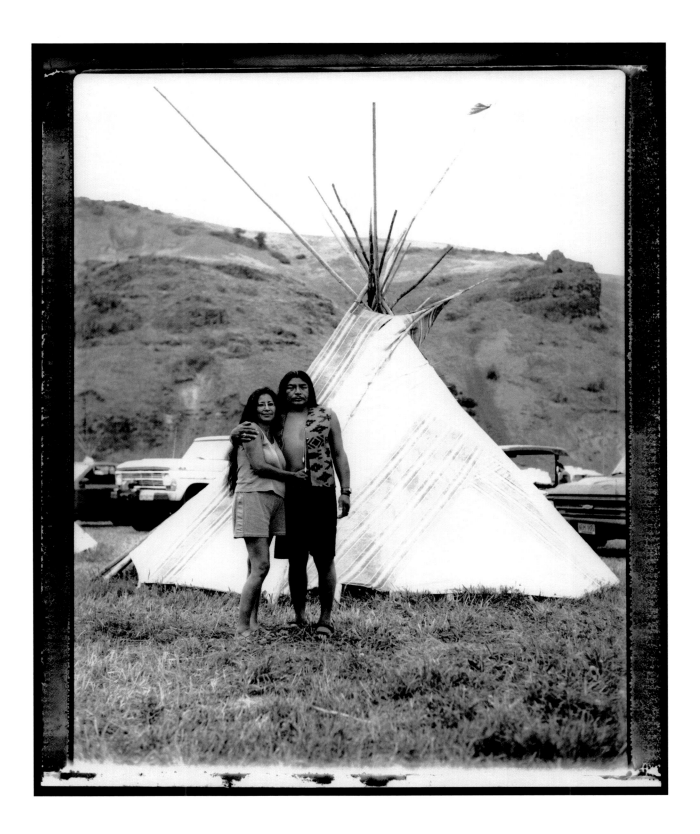

Spirit
Tamkaliks Powwow, Wallowa, Oregon

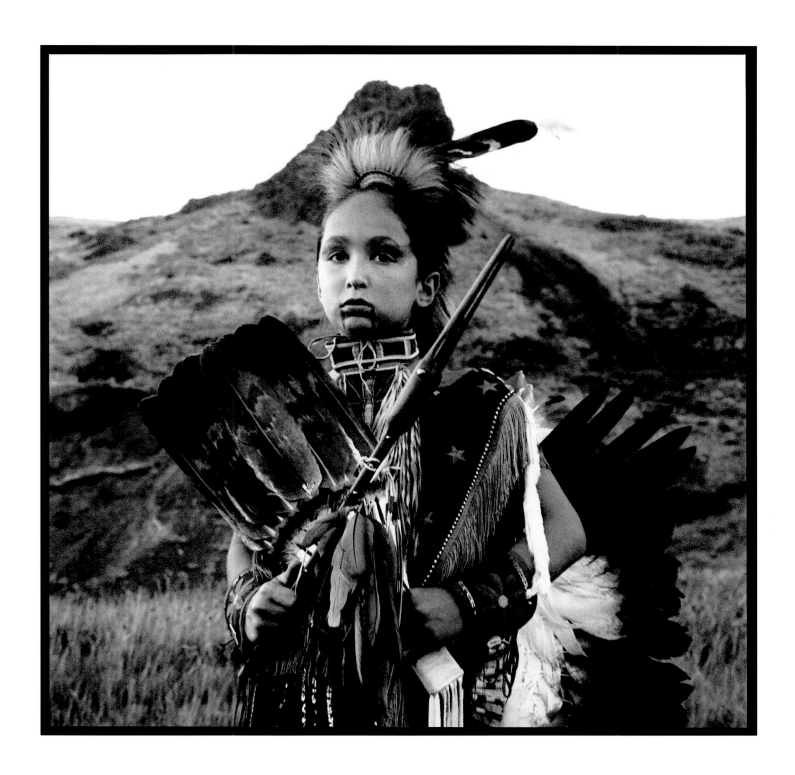

Sweatlodge
Lapwai, Idaho

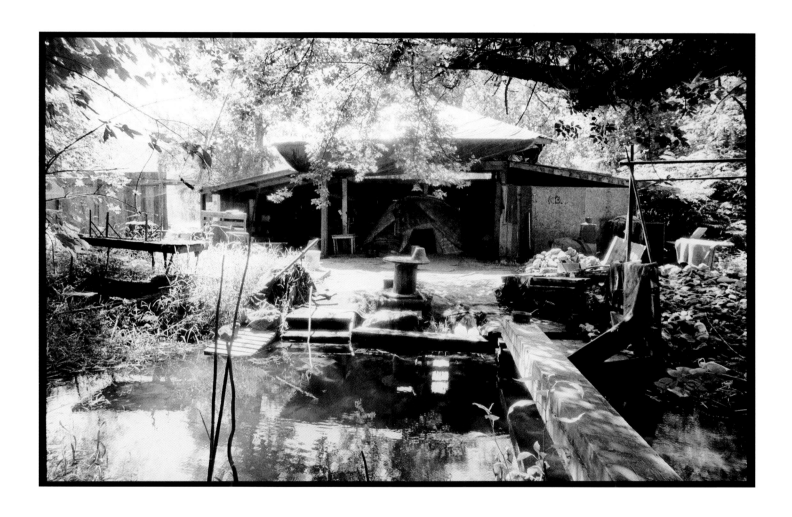

Hun¯yawat / Sweatbuilder
Lapwai, Idaho

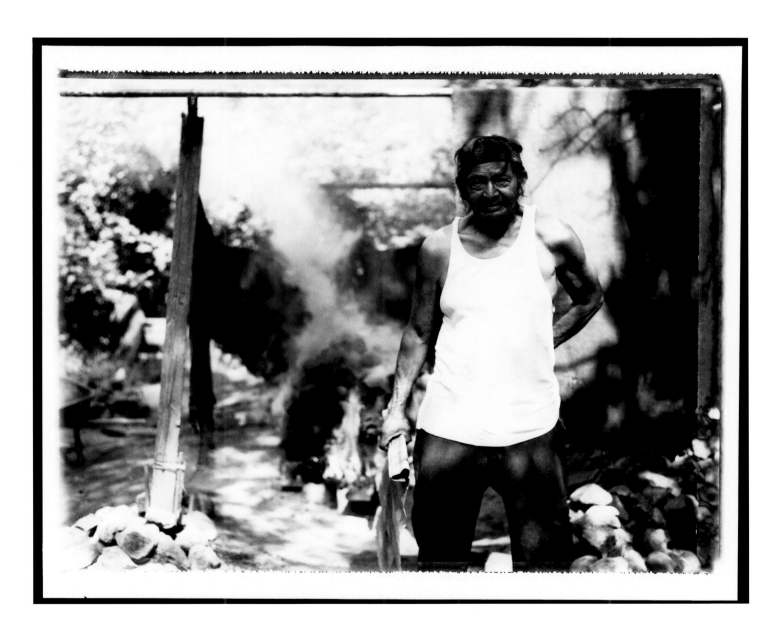

Rez Girls
Lapwai, Idaho

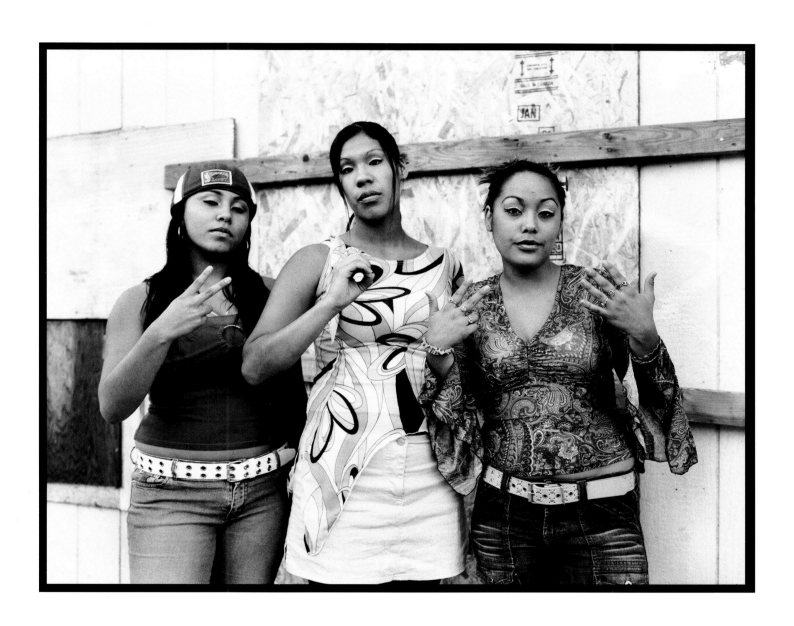

Gaylen Broncheau
Spalding Park, Idaho

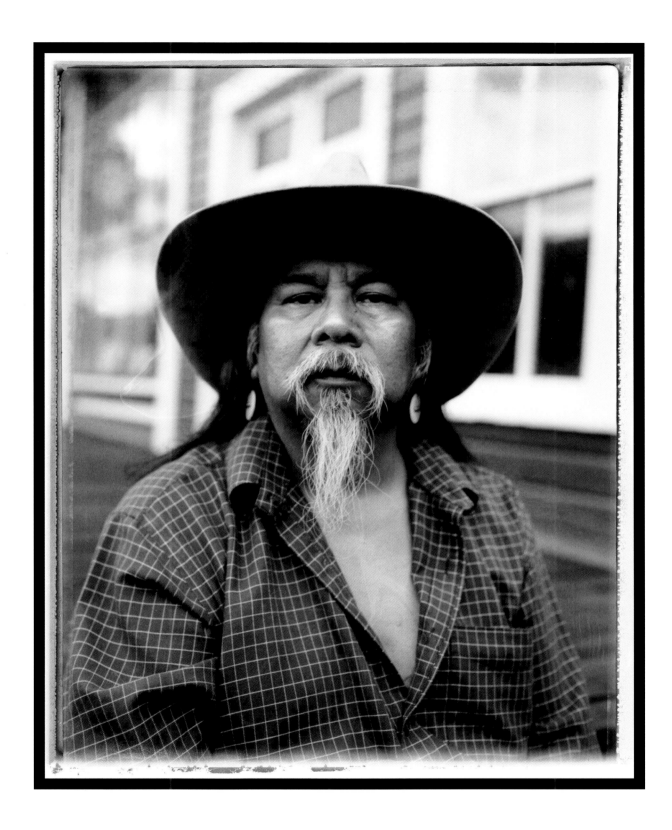

Four Directions
Nespelem, Washington

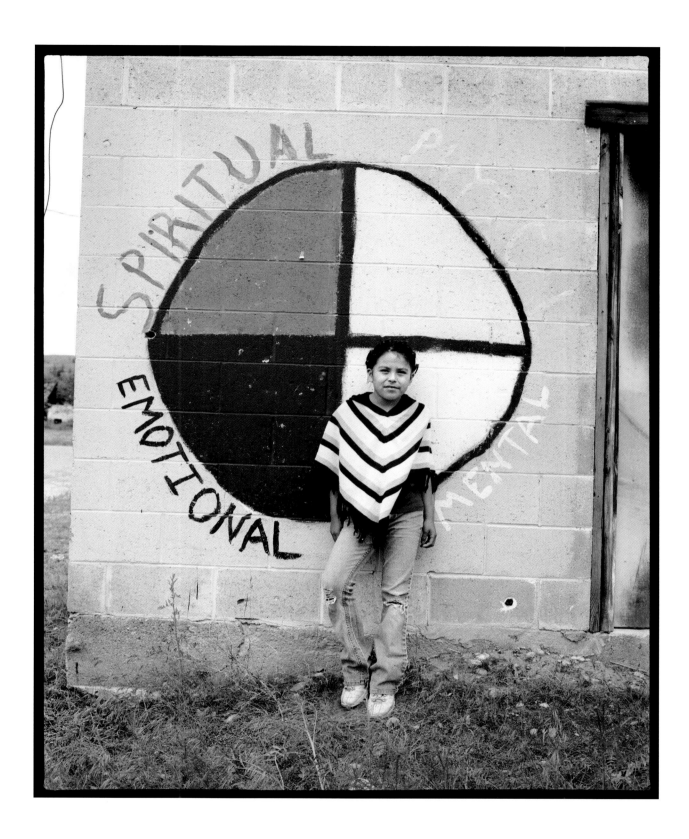

Gus In The Wind
Nespelem, Washington

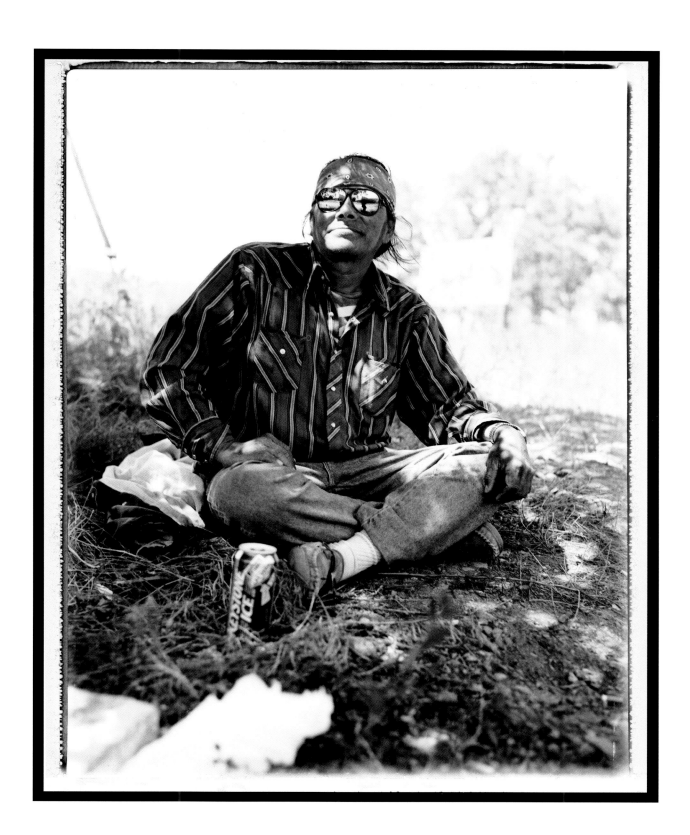

Lucille Pakootas
Nespelem, Washington

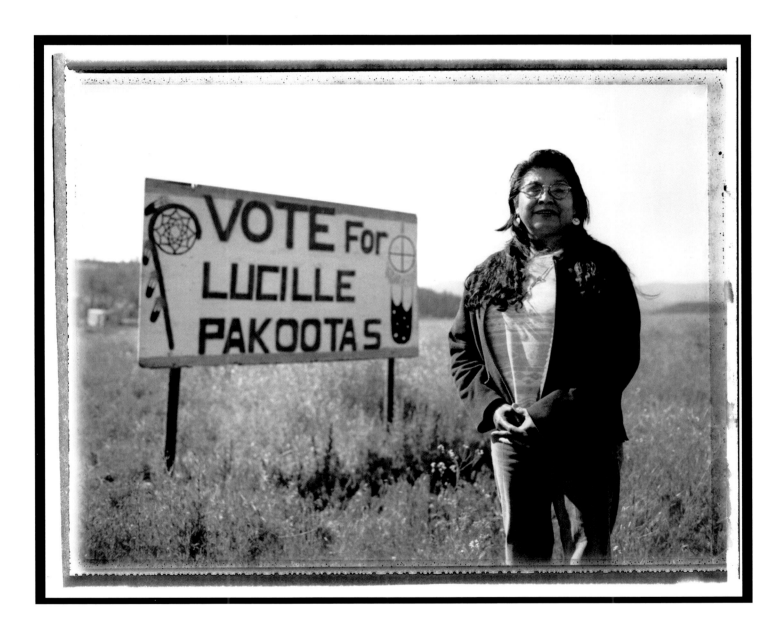

Jeff
Lapwai, Idaho

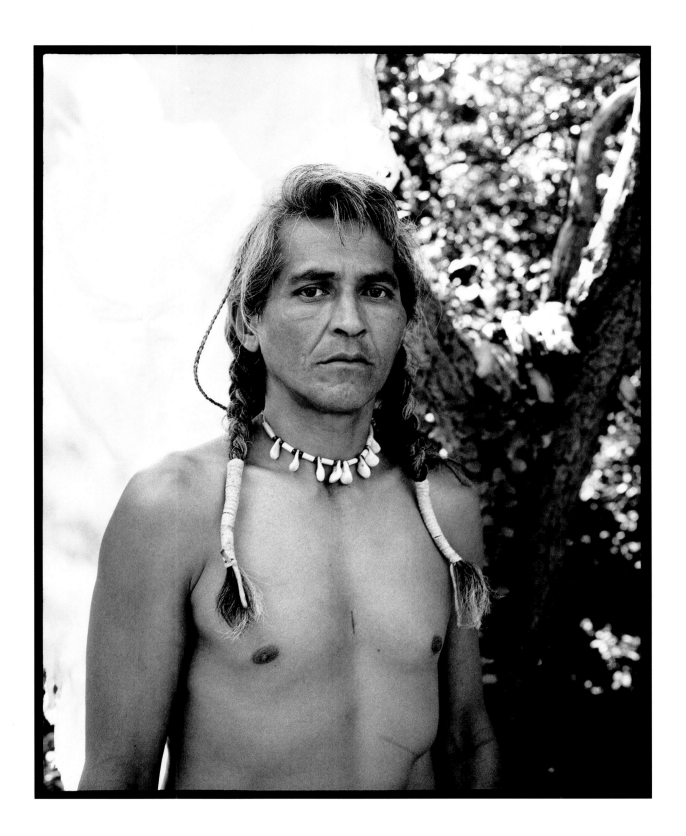

Uncle Irving
Lapwai, Idaho

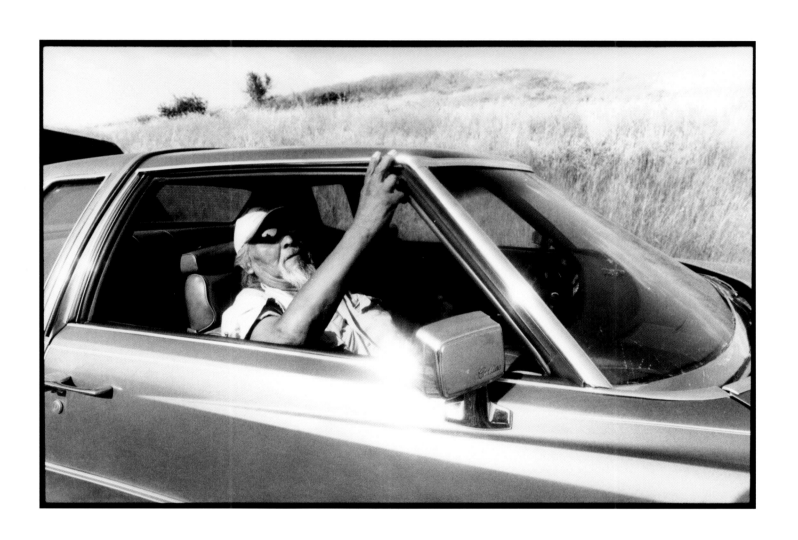

Entrance To Mud Camp
Lapwai, Idaho

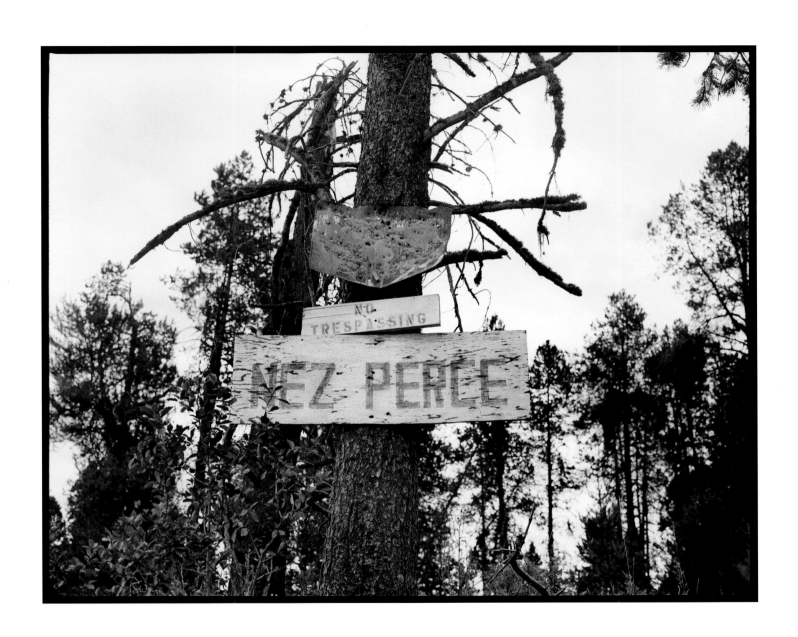

Mud Camp
Lapwai, Idaho

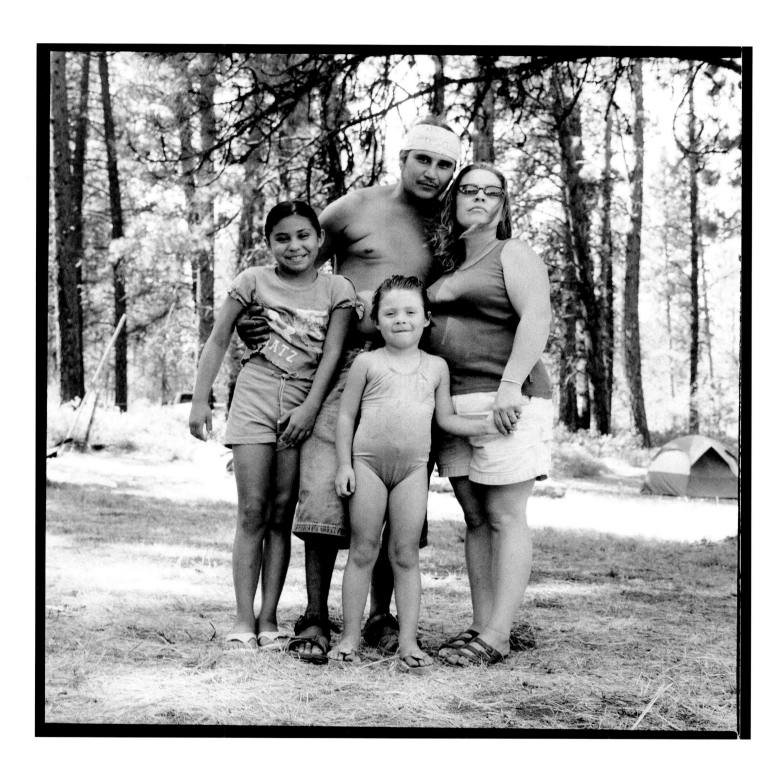

Red Grizzly
Lapwai, Idaho

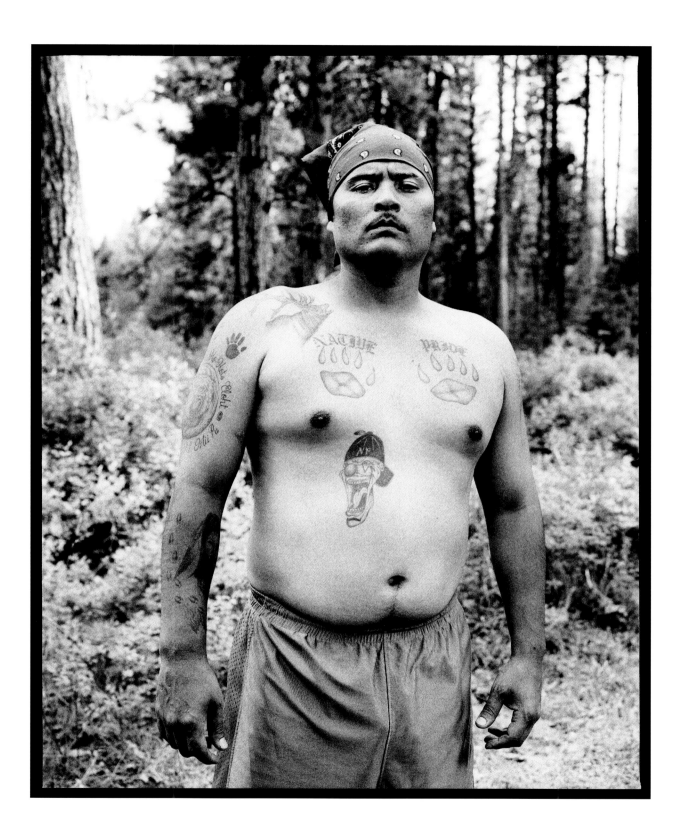

Old Timer
Lapwai, Idaho

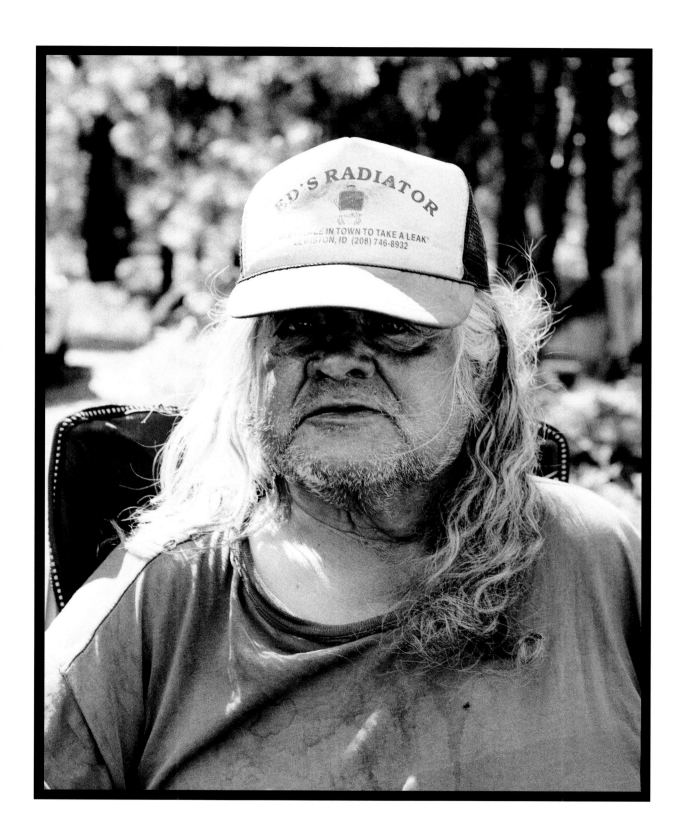

8:00 a.m. Sunday Morning
Lapwai, Idaho

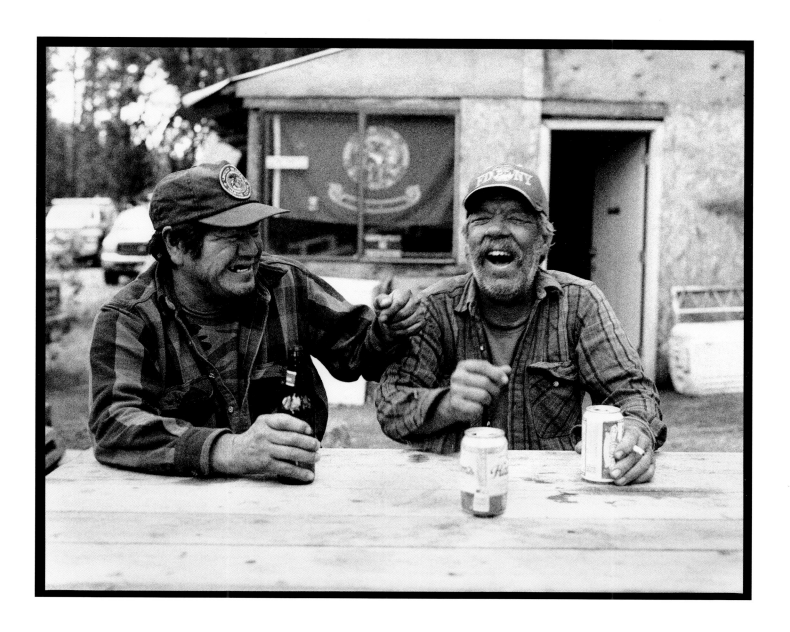

Grandma
Lapwai, Idaho

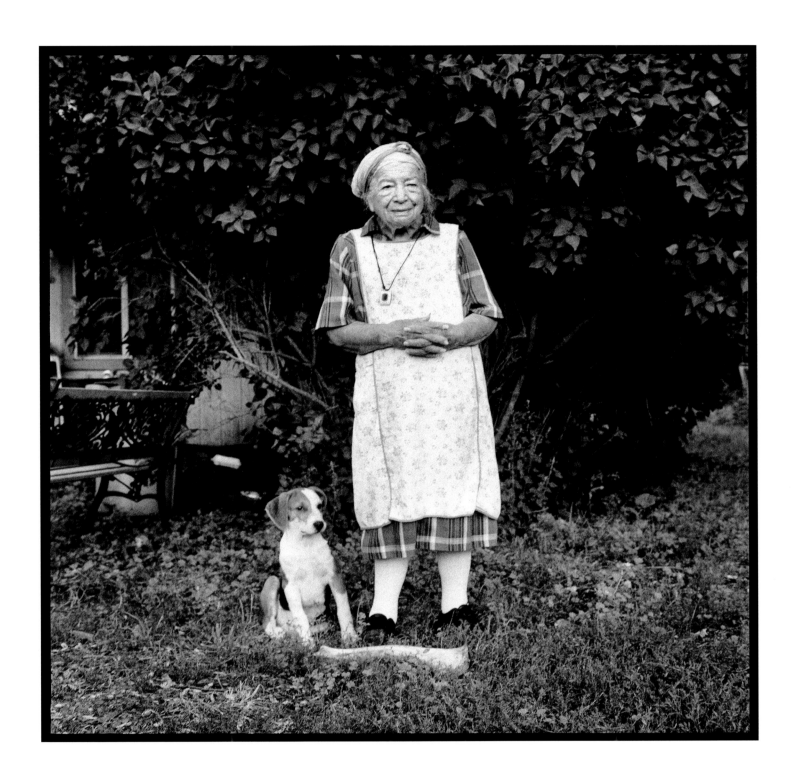

Grandpa
Tamkaliks Powwow, Wallowa, Oregon

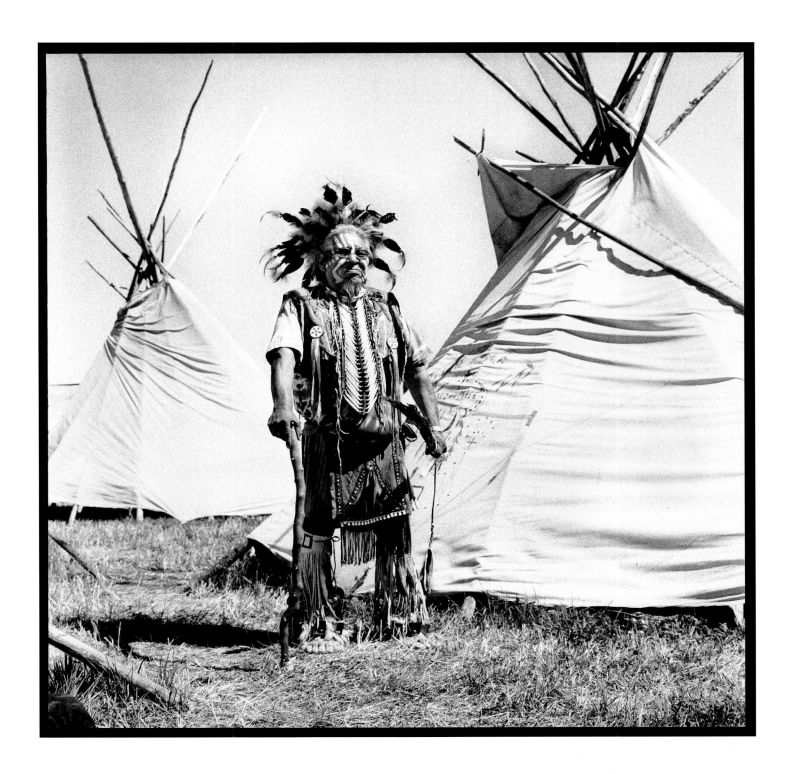

Lookingglass
Lookingglass Powwow, Kamiah, Idaho

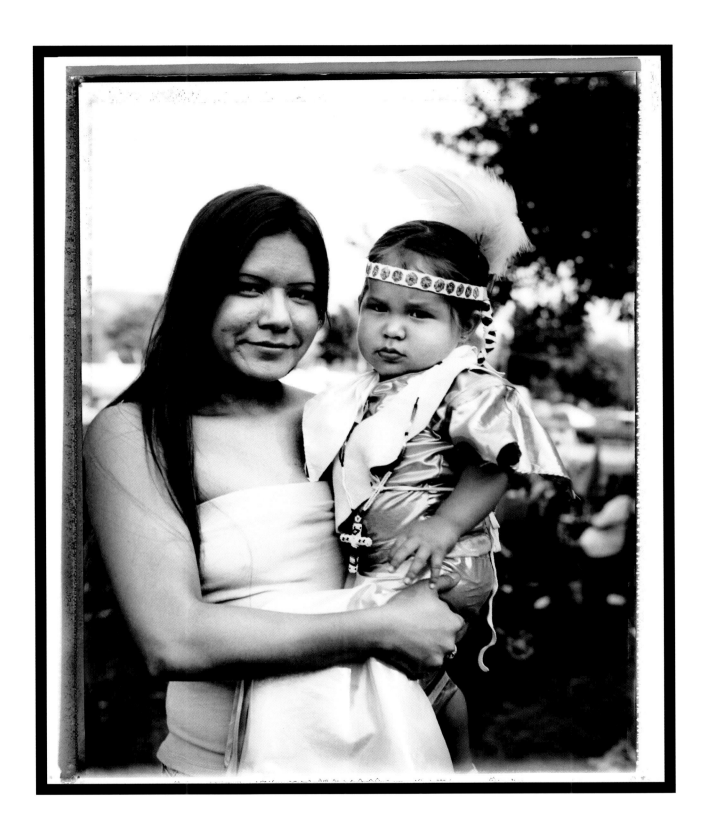

Tracy
Lapwai, Idaho

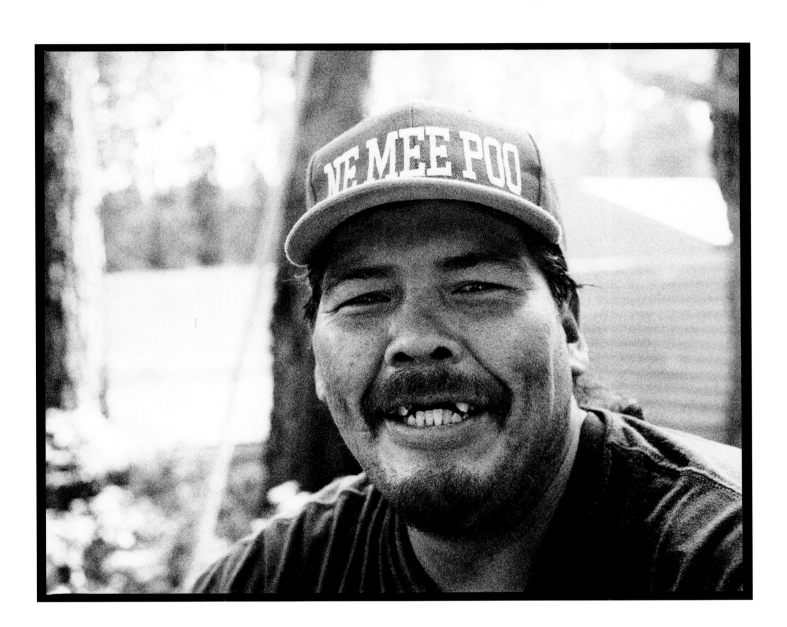

Non-Treaties
Lapwai, Idaho

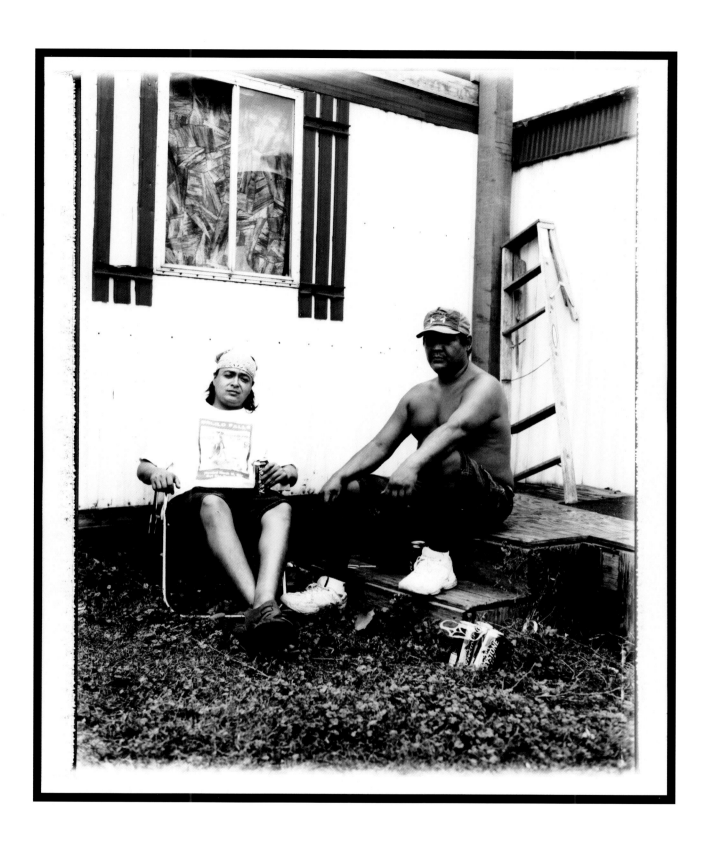

Zomber
Lapwai, Idaho

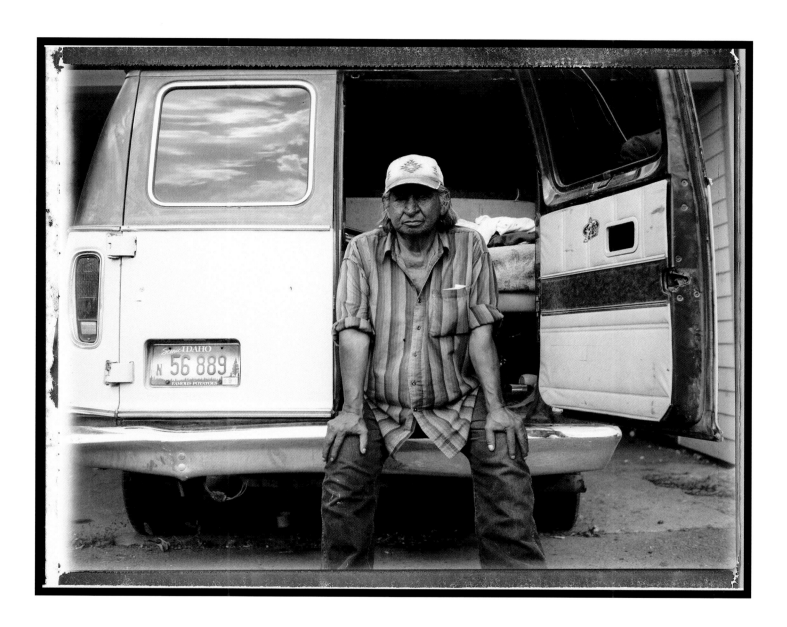

Thunderbird
Lapwai, Idaho

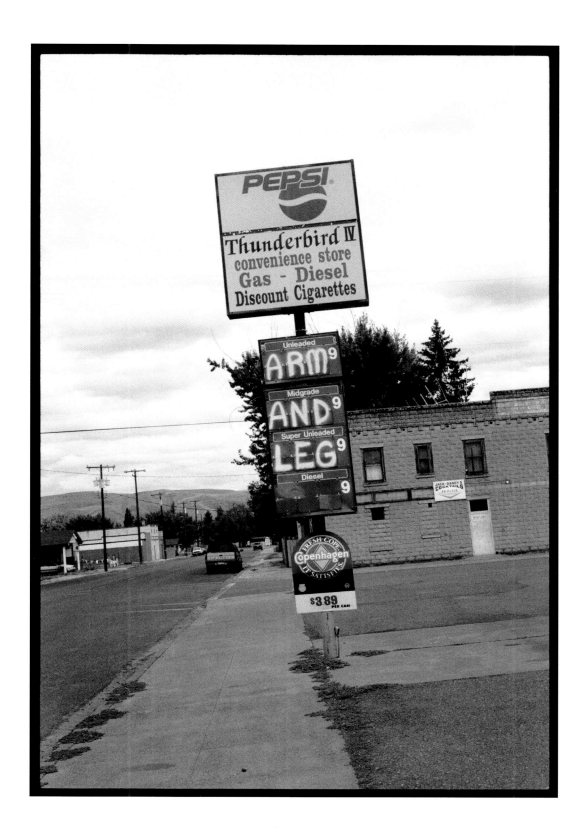

Montana Band
Lookingglass Powwow, Kamiah, Idaho

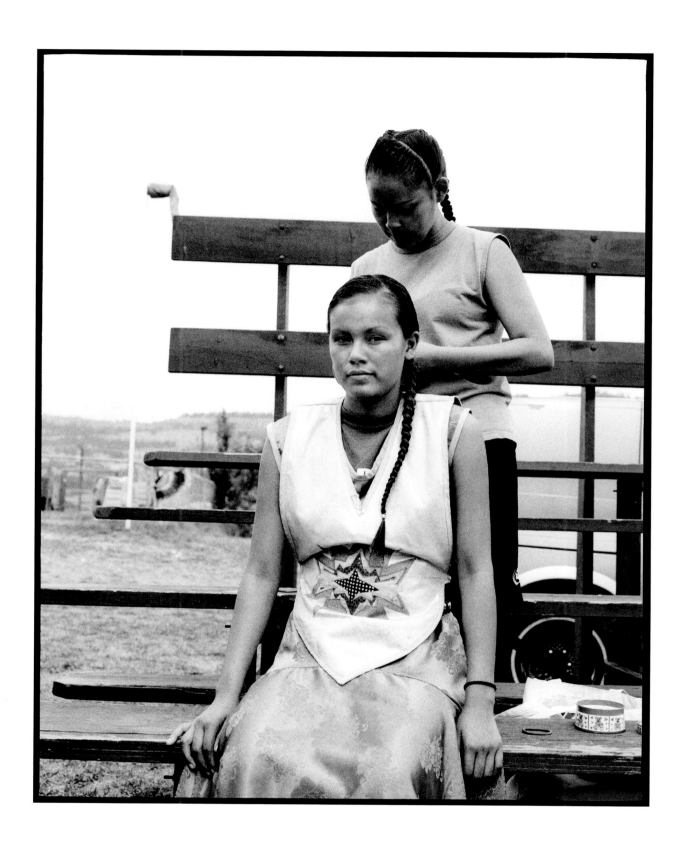

Nancy Minthorn
Tamkaliks Powwow, Wallowa, Oregon

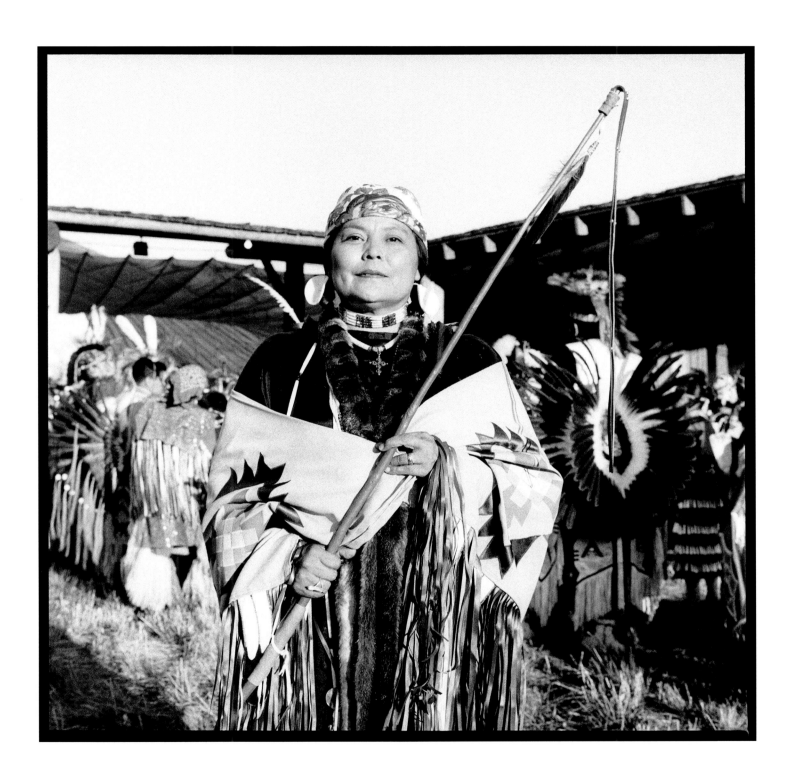

J.T.
Tamkaliks Powwow, Wallowa, Oregon

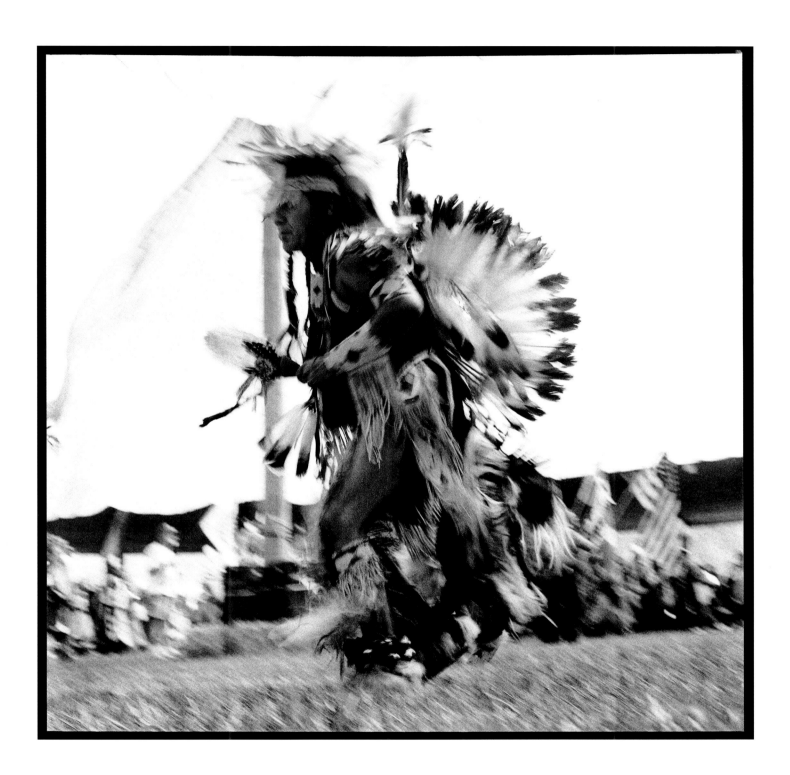

Sky Dancer
Tamkaliks Powwow, Wallowa, Oregon

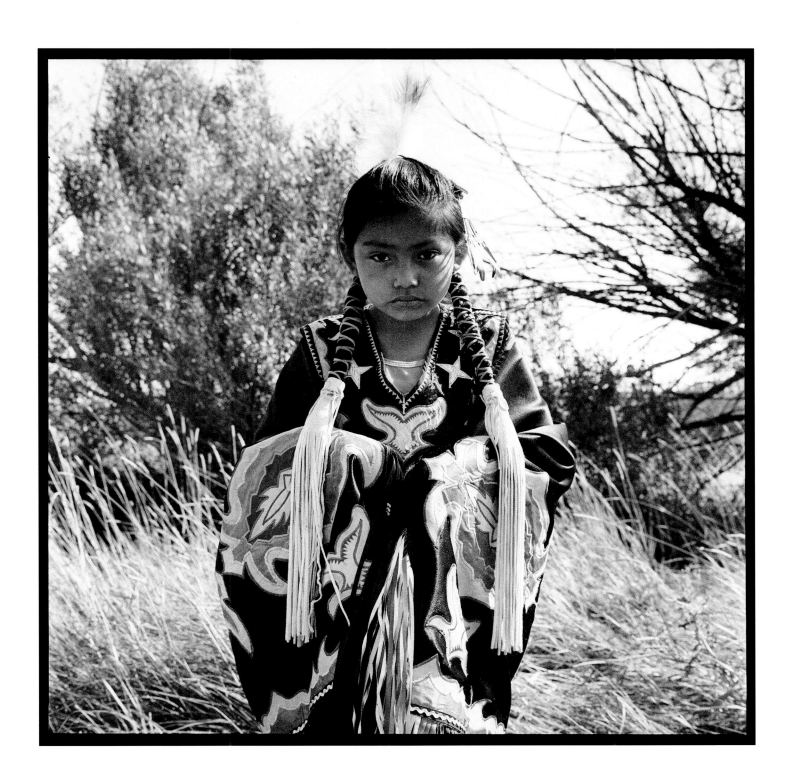

Powwow
Tamkaliks Powwow, Wallowa, Oregon

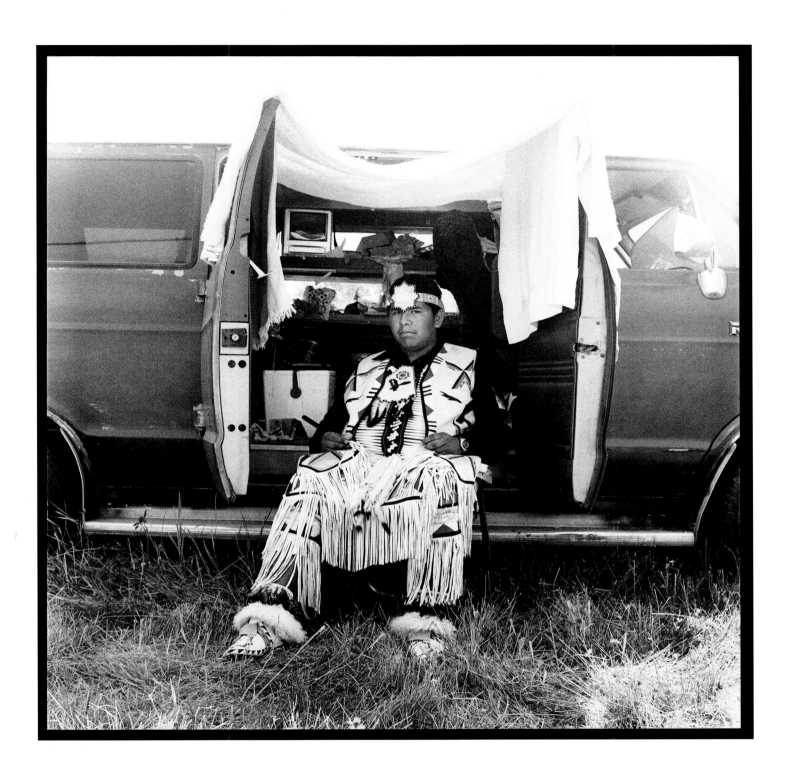

Smokehouse
Tamkaliks Powwow, Wallowa, Oregon

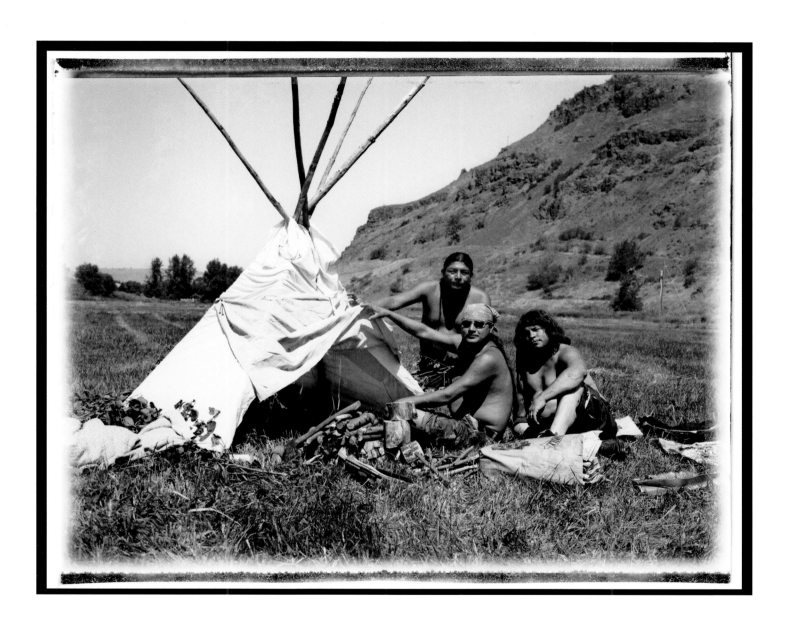

Feeding The Family
Inchelium, Washington

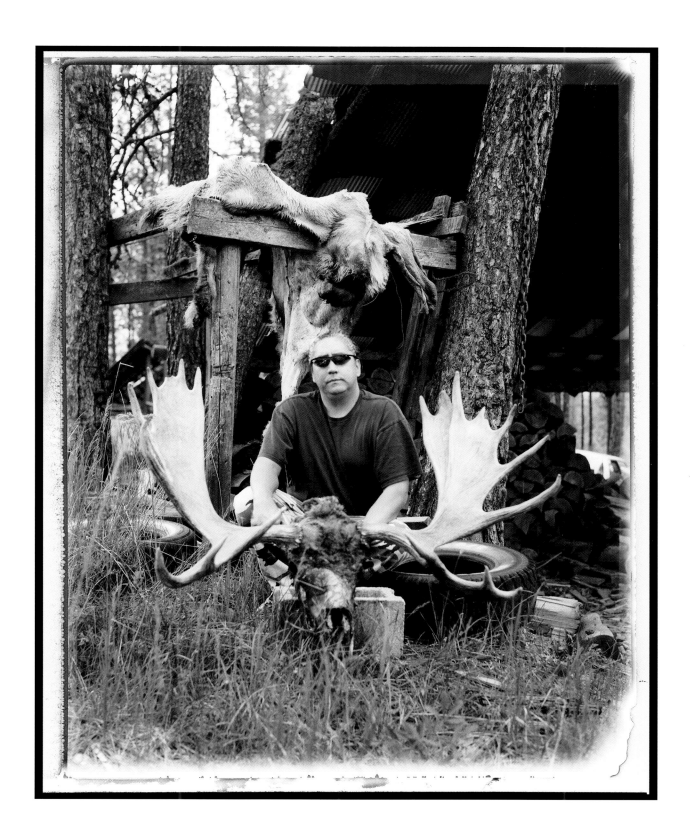

Floyd And His Grandson
Inchelium, Washington

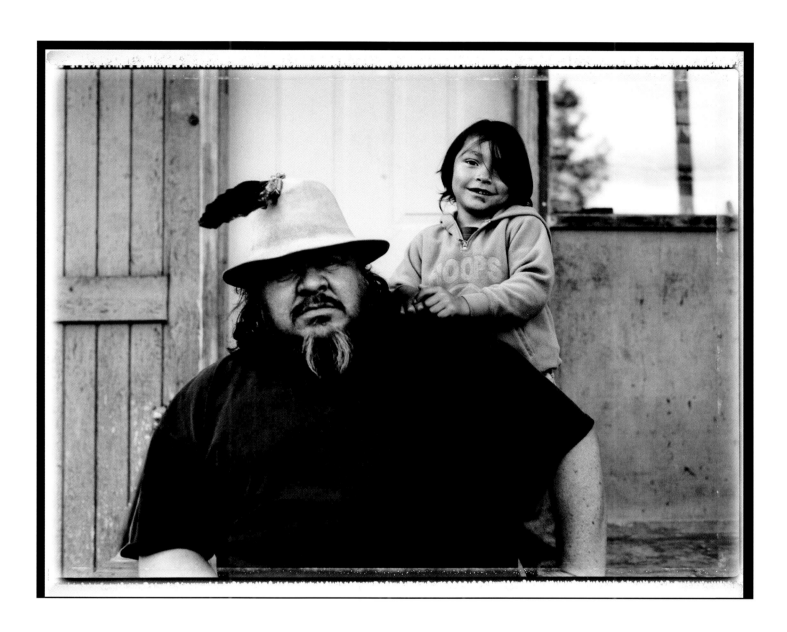

Ed Covington
Nespelem, Washington

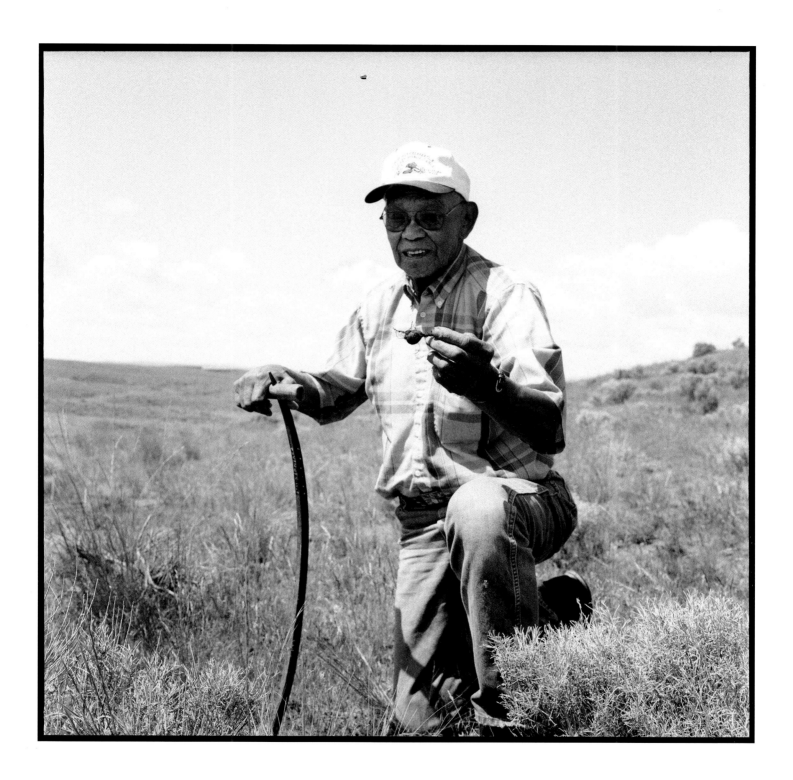

Coyote Sweat
Nespelem, Washington

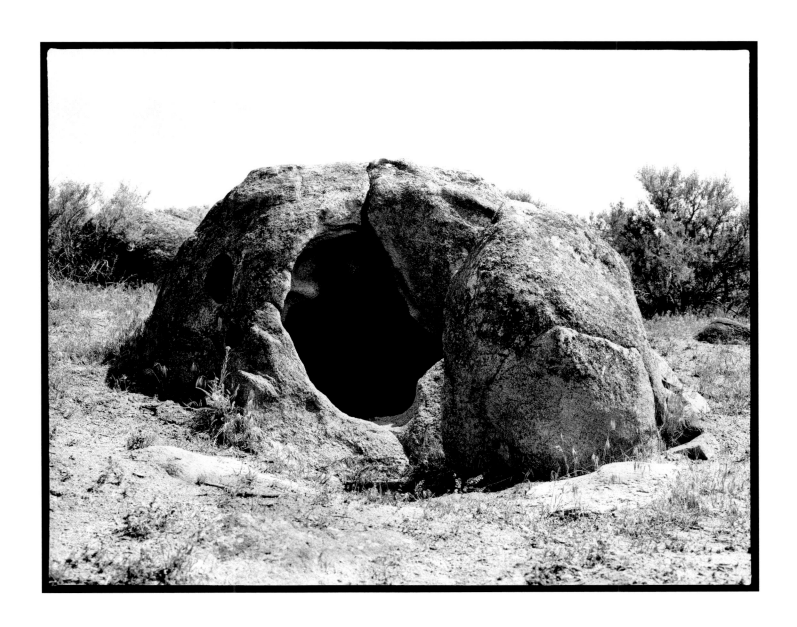

Cindy Rez
Inchelium, Washington

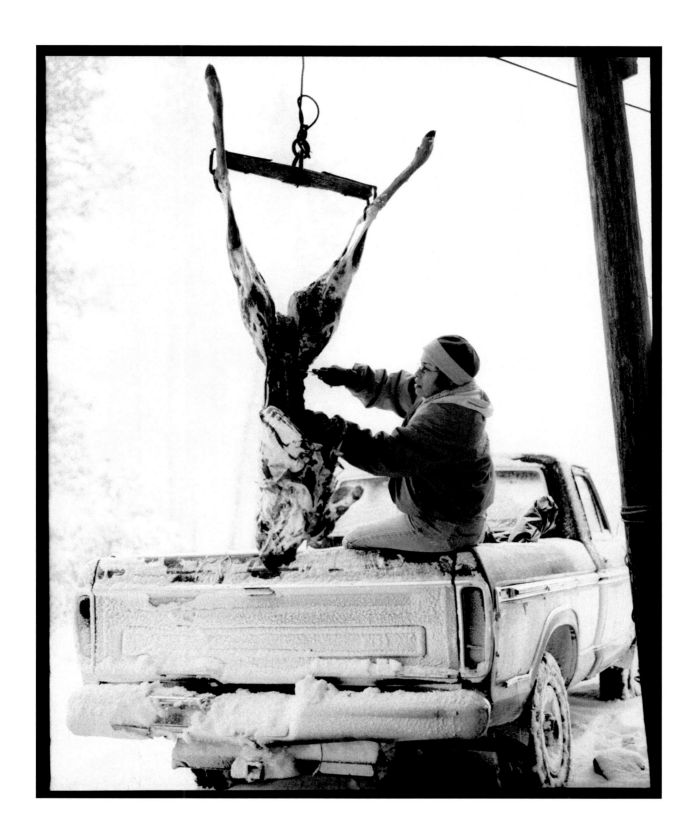

Waddy's
Lapwai, Idaho

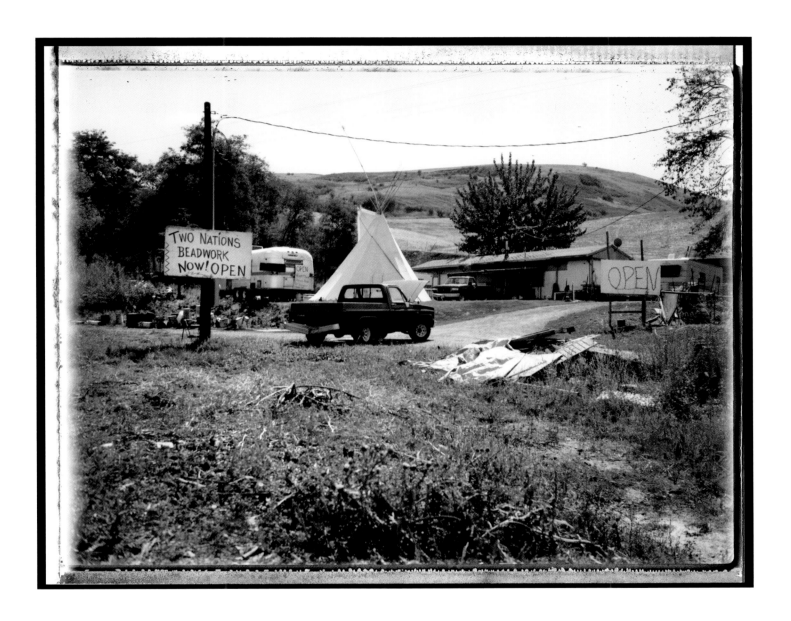

Waddy
Lapwai, Idaho

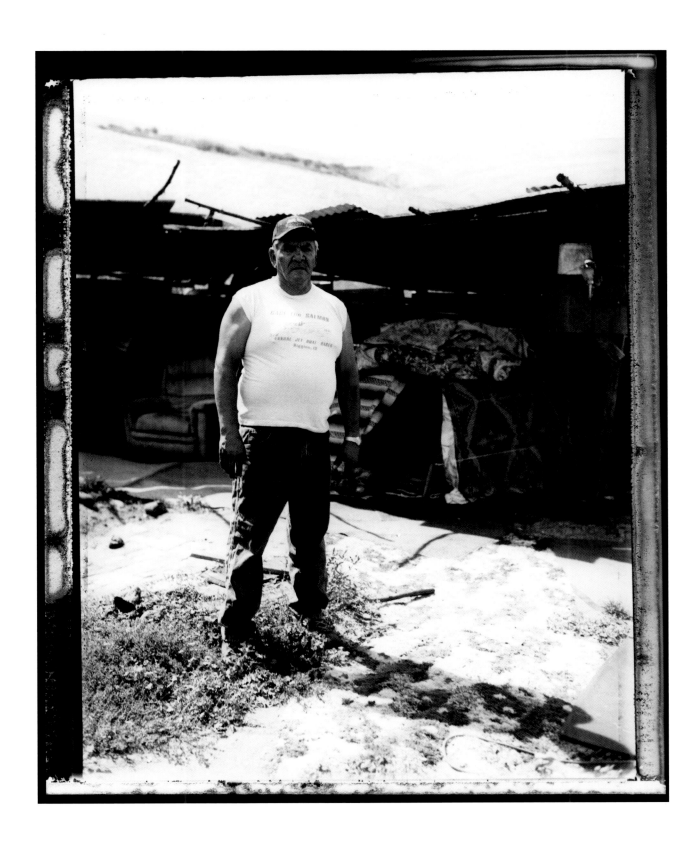

Local Rodeo
Nespelem, Washington

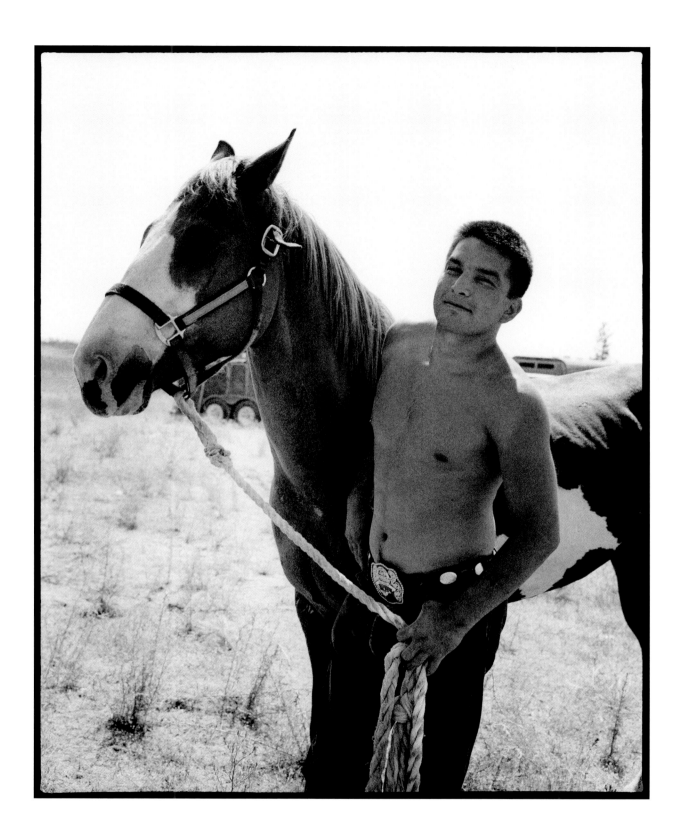

Play
Lapwai, Idaho

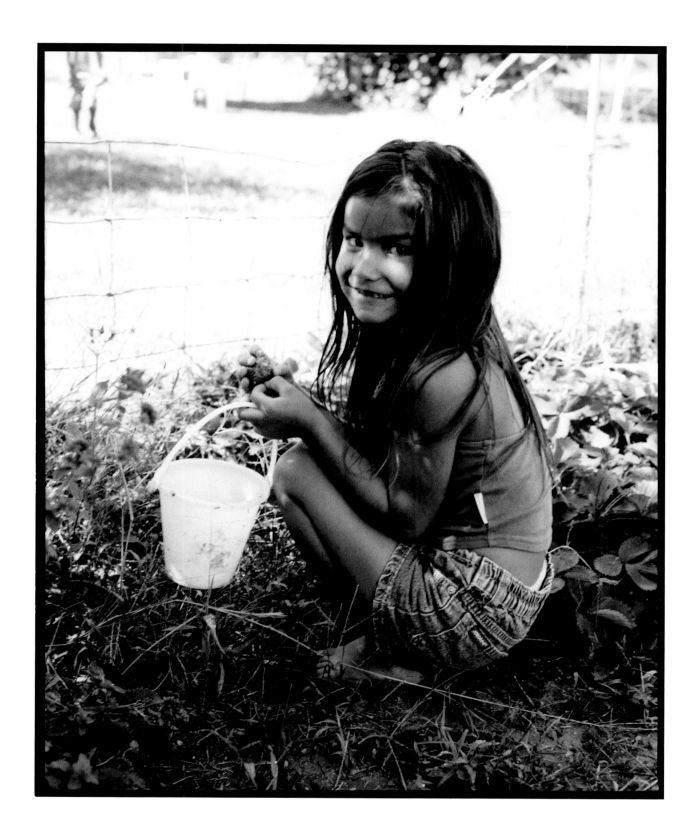

Paschal Sherman Indian School
Omak, Washington

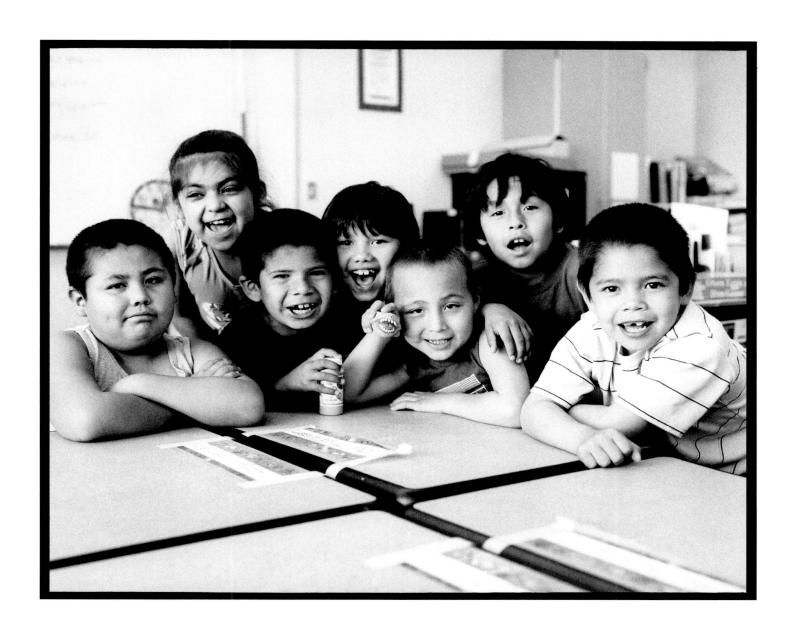

Kash Kash Family
Lapwai, Idaho

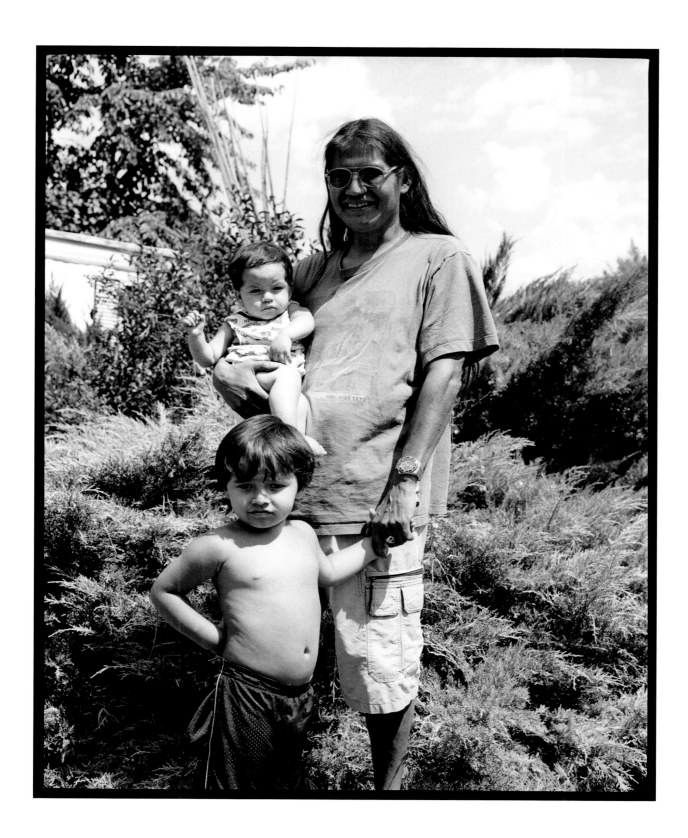

Nim
Tamkaliks Powwow, Wallowa, Oregon

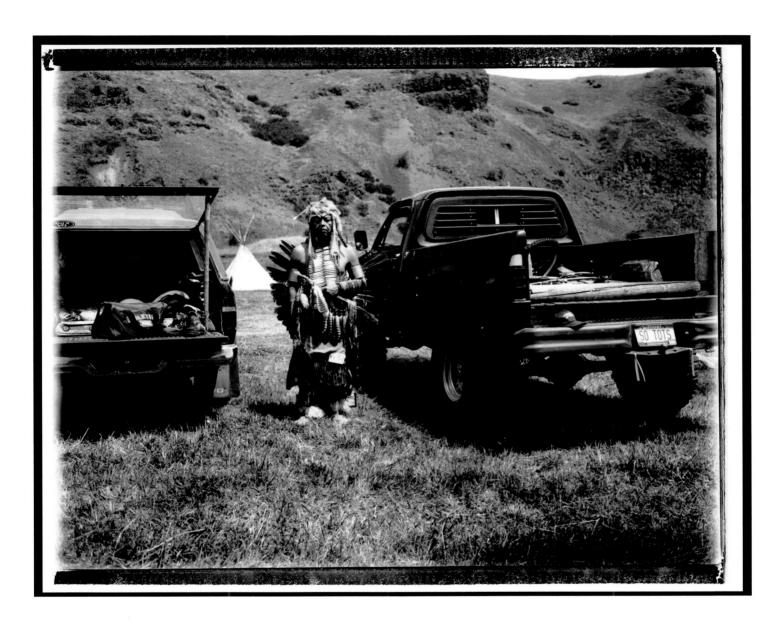

Salmon Brothers
Tamkaliks Powwow, Wallowa, Oregon

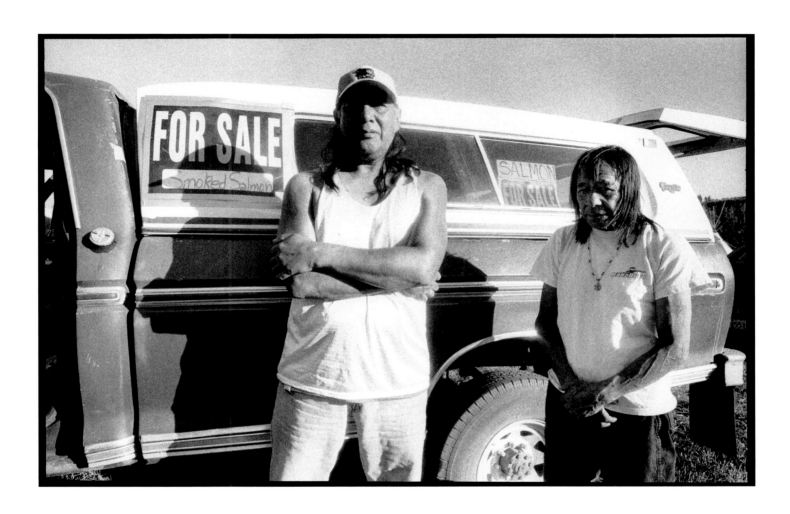

Inchelium Moccasin Hud
Inchelium, Washington

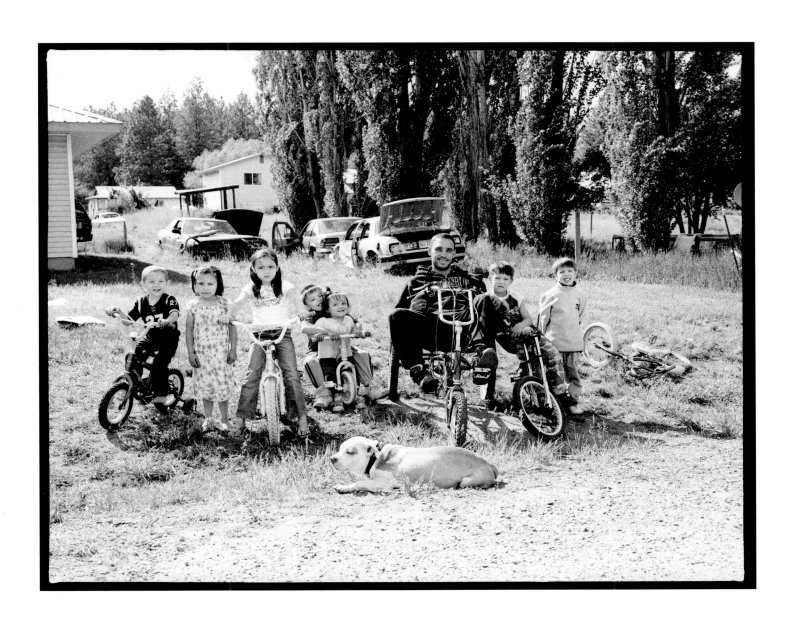

Cindy Wapato
Joseph, Oregon

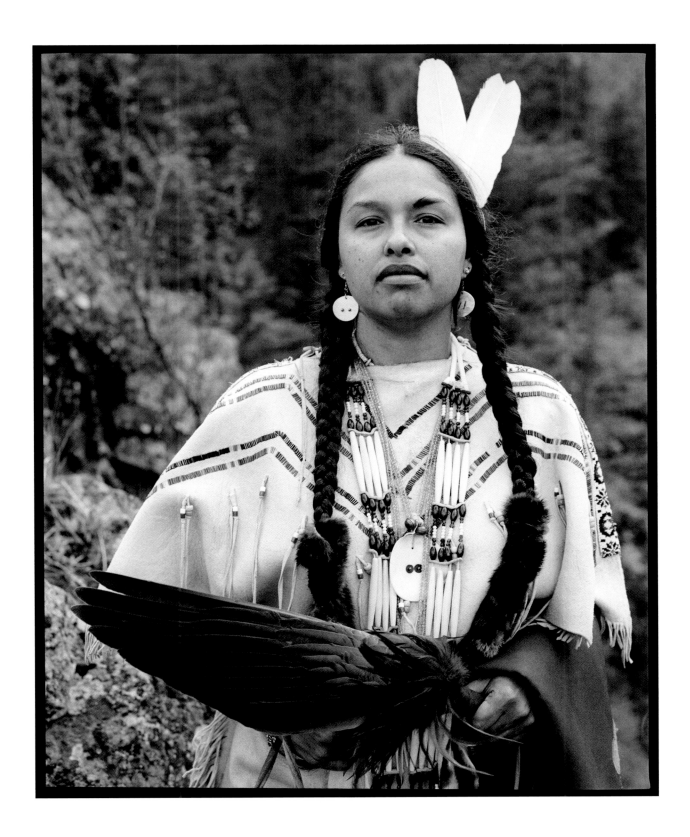

Chief Joseph's Grave
Nespelem, Washington

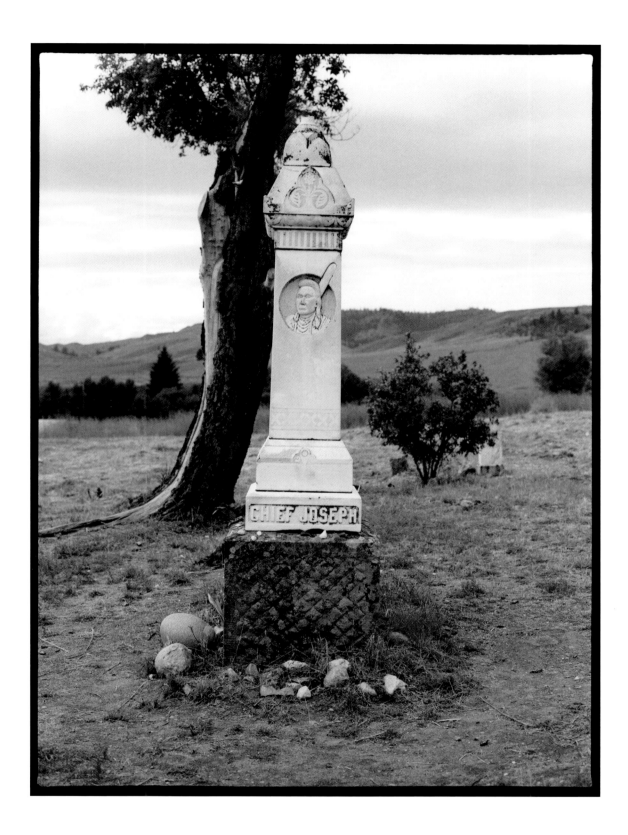

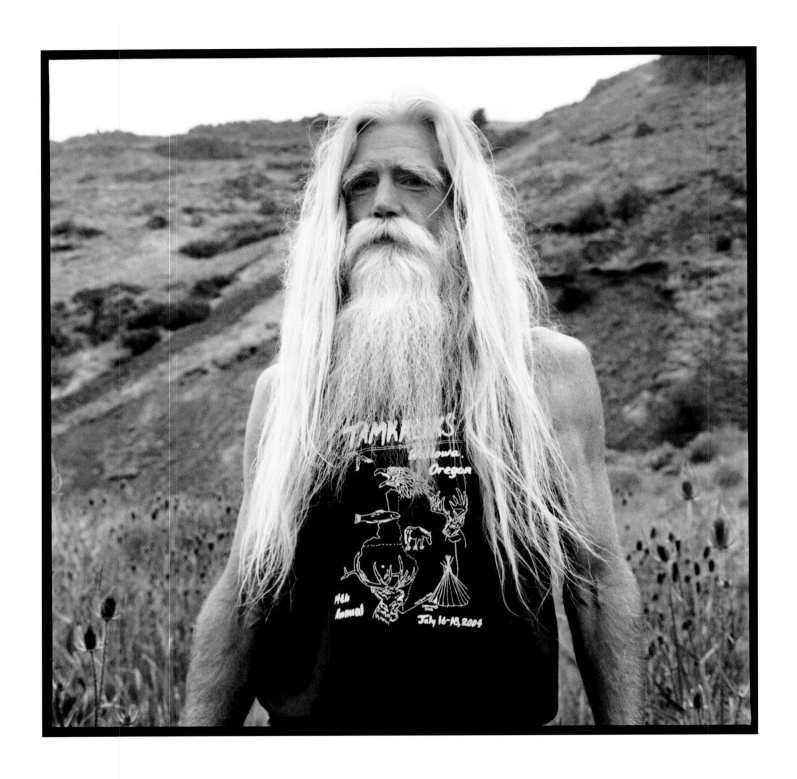

Peace Maker
Tamkaliks Powwow, Wallowa, Oregon

The Story Of Paul Howard

In 2004 a new guest arrived at the Tamkaliks Powwow.

They called him The Wizard, not knowing his name.

He had a long white beard with flowing hair, walking with intention in his eyes.

He came with a reason held deep inside.

During this time he asked to speak to the people of the tribe.

Standing in front of those who were there he stated he was the great great grandson of General O.O. Howard. Expressing his feelings of what his ancestors had done he shook in sorrow.

The braids of the people were cut and through battle the reservation was formed. History he had learned later in life was said.

As a sign of grief and forgiveness he would cut his hair. Turning the sword as a symbol of wrongdoing into a knife, his locks were cut. Giving both the knife and his hair to the tribe.

His statement was honored that day, passing eagle feathers hand in hand.

Paul Howard now returns each year.

Embraced together sharing their sacred ways.

Hunter Barnes

Thank You

The People of the Nez Peace Tribe	Alec Sam	Janine Corletta
Andrea Castagno and August Eagle	Doug	John and Travis
All my family	Nancy Minthorn	Robert Heist
Mom	Mazdack Rassi	Danny Miller
Dad and Lorena	Jason Cannon	The Castagnos
My brothers and sisters	Dave D'Amico	Jos and Annabel
Tony Nourmand	Noot Seear	Damien Massingham
The Endeavor Foundation	Erin Wasson	Jill and Basil
Julie Kidd	Gibby Haynes	Jassine Chrisphonte
Charlotte Kidd	Lucy Ekstrom	Lou Kurpis
Yasha Sturgill	Justin King, LTI	Tony Cummings
Cindy Wapato	Patty Katchur	George Merck
The Hawkins Sisters	Alison Elangasinghe	Brandon Pavan
Eric Borgerding	Dave Brolan	Josephine De Freitas
The Chitwoods	Rory Bruton	Rose Charities
Chris Buhler	Joakim Olsson	Hanks Photographic Services
David Lundquist	Jesse Mathews	Jamie Biden
Uncle Irving Waters and his family	Zach Adams	Song Chong
Gaylen Broncheau	Haas Colby	Kana Manglapus
J.T., J.C. and Bob Kash Kash	Alex Hayden	Todd and Megan DiCiurcio
Butch	Cheyann Benedict	Bob Melet
Community Sweat	John Lansing	Annie Henley
Gib	Nicole Trunfio	David Hemphill
Justin	Willow Graham	Nathan and Johanna
Gary	Carolyn Murphy	Dale Beckman
Ed Covington	Ken Hunt	Radek Valahovic

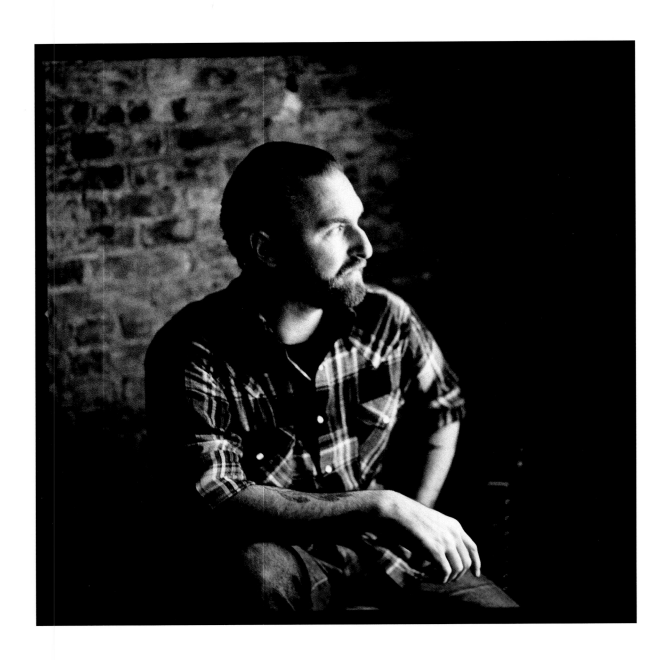

Hunter Barnes by Charlotte Kidd

Hunter Barnes

Hunter Barnes (b.1977) is one of the foremost documentary photographers working in America today. His photographs document aspects of culture and communities ignored by the mainstream and often misrepresented in the modern American narrative.

Hunter trained in photochemistry and traditional photographic techniques. At a young age, he began a nomadic life on the road. "For years I've traveled with my cameras capturing moments of time with the people the road has led me to. . . . A glimpse into parallel worlds traveling in circular motions."

In his early twenties, Hunter self-published his first book, *Redneck Roundup*, documenting the dying communities of the Old West. Other projects followed: four years spent with the Nez Perce tribe; months with a serpent handling congregation in the Appalachian mountains; bikers, lowriders, and street gangs; inmates in California State Prison. Intense, true pockets and sub-cultures of America.

The process is an integral part of Hunter's work. He shoots exclusively on film—the pace of analogue in harmony with his approach. "Certain cameras and film have souls. It's not immediate and has more meaning. I have time to develop relationships with the people I'm with. There is a different respect for it, they sit there with you and every shot counts." Fundamental to Hunter's work is the journey, the people, the place. Then committing them to film before they are greatly changed or gone forever.

The People is Hunter Barnes's eighth publication. All his books have been printed as limited editions of 1000. Also available are *Redneck Roundup* (2002) and *Outside of Life* (2004); and from Reel Art Press: *A Testimony of Serpent Handling* (2012), *Roadbook* (2015), *Tickets* (2017), *Off the Strip* (2018) and *Spirit of the Southern Speedways* (2019).

This book is a limited edition of 1000 copies

Art direction and design by Joakim Olsson

Image scanning and retouching 2019 by Haas W. Colby / Velem
Lettering and image scanning and retouching 2008 by Jesse Mathews
Image production and archiving by Zach Adams
Pre-press by James Cowen

First published 2020 by Reel Art Press, an imprint of Rare Art Press Ltd, London, UK

reelartpress.com

First Edition

10 9 8 7 6 5 4 3 2 1

ISBN: 978-1-909526-75-4

Printed by Graphius, Gent